IMAGES
of America

RHODE ISLAND
RADIO

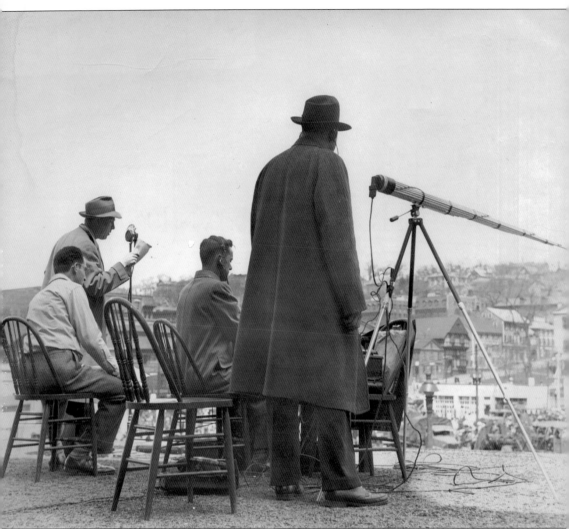

ON THE COVER: Ed Pearson (left, at the microphone), while at WPRO and later at WPJB-FM, was well known for his descriptions of local parades and public events. With longtime technicians Bob Morgan and Jerry Lampinski by his side at both stations, Pearson set the standard for local coverage. (Mary Lou Pearson.)

IMAGES
of America

RHODE ISLAND
RADIO

John Rooke
Foreword by Gary Berkowitz

ARCADIA
PUBLISHING

Published by Arcadia Publishing
Charleston, South Carolina

Printed in the United States of America

Library of Congress Control Number: 2011933371

For all general information, please contact Arcadia Publishing:
Telephone 843-853-2070
Fax 843-853-0044
E-mail sales@arcadiapublishing.com
For customer service and orders:
Toll-Free 1-888-313-2665

Visit us on the Internet at www.arcadiapublishing.com

*This book is dedicated to the men and women who have created such
a fascinating industry in a fascinating state . . . and to my mother, the
late Judith Daveen Johnson Rooke, who always told me I could do this.*

CONTENTS

FOREWORD

From the first time I heard "This is the station that reaches the beaches" through WPRO's massive reverb system, I knew that Providence radio was where I wanted to be. That was back in 1971, while I was attending Emerson College in Boston. Being a native New Yorker, I loved all the new stations I could listen to in Boston, but it was the stations from Providence that really grabbed my attention.

I began at WPRO as an intern, worked my way into a weekend air slot, then a full-time slot, and eventually became the first program director at the now legendary 92 PRO-FM. I had some fabulous years in Providence getting to be part of the WPRO-WICE ratings battle. WJAR, owned by The Outlet Company, took their shot at us, and, finally, the now famous WPRO-WGNG battle took place. When PRO-FM came around, that ended the battle for Top 40 on AM, but it opened the floodgates for the PRO-FM–JB105 battle. We know who won that one because, 38 years later, PRO-FM is still with the same format, in the same building, and at the top of the ratings!

Some of the greatest air talent and programmers have come through Little Rhody. Recently, at the Rhode Island Radio Hall of Fame induction, I was thinking about my early days on WPRO, when I followed the legendary "Big Ange" (John Manzi). That was no easy task, as he was arguably one of the greatest top 40 jocks ever, and here I was, the young, new kid on the block with the small voice!

Big Ange was only one of the many Rhode Island radio legends that I had the chance to work with over the years and that the listeners got to hear on a regular basis. Salty Brine, Bud Toevs, Jimmy Gray, and Charlie Jefferds are just a few examples of radio guys who could have easily left for bigger markets but made Rhode Island their home.

My time in Rhode Island shaped the fabulous career I have subsequently enjoyed in radio. Becoming the program director of WPRO-FM changed my radio life forever. Rhode Island gave me and hundreds of broadcasters the chance to practice our craft in a warm and welcoming market.

Enjoy John Rooke's *Rhode Island Radio*, knowing that everyone who is a part of this state's rich radio history had a ball doing it for you!

—Gary Berkowitz
Berkowitz Broadcast Consulting
Detroit, Michigan
Rhode Island Radio Hall of Fame Shepard Award recipient, 2012

ACKNOWLEDGMENTS

There is simply no way this record of radio history in Rhode Island could have been completed without the help of several passionate people. Former WPRO jock, program director, and AC Top-40 format king Gary Berkowitz shared his knowledge of the industry from the 1970s, as well as his photographs. Thank you to Jeff Falewicz, also known as Tom St. John, who was most helpful with his contributions and advice; to Barbara Smith, who can tell great stories about the personalities on (and off) the air on the Wampanoag Trail inside the "Brine Shrine"; and to Wally Brine, Salty's son and an on-air personality in Boston, who provided valuable information. Thank you to Gene Hutnak, Holland Cooke, Ron St. Pierre, John Colletto, Bobb Angel, Dave Richards, Dave Russell, Roger Bouchard, Gene and Gary DeGraide, Bill Corsair, Dick Poholek, Andy Lamchick, Jacci Grillo, Deb Rich, Scott Cordischi, Vin Ciavatta, Anthony Pescarino (aka Tony Bristol), Daniel (Giovanni) Centofanti, Donald Clark, Gigi Edwards, Tim Gaulin, Paul Zangari, and George Patrick Duffy for their insight and contributions as well.

Thank you to Hilary Zusman at Arcadia Publishing, who originally asked me to undertake this effort and who convinced me that this project would be worthwhile. Little did I know. . . . And I sincerely appreciate the patience of Lissie Cain at Arcadia, who picked up my "project" and kept pushing me and motivating me to be on the lookout for photographs that tell "stories." Likewise, my girlfriend, Robin Arruda, kept me sufficiently motivated when the possible suddenly became impossible.

Without the help, input, and passion from Marie Louise Pearson, this project does not get completed. Marylou's love for her father, the late Ed Pearson, knows no bounds. She is fiercely proud of her father's accomplishments and of what his career meant to this industry within Rhode Island, as we all should be. Her collection of photographs, newspaper advertisements, and memorabilia from her father's career—handed down to her after he retired in the 1970s—is extensive, and much of it is shared within these pages.

INTRODUCTION

I fell into radio by chance. After persuading my academic dean that I would graduate early so I could qualify for an internship held open for older students, I worked at KTRH-AM in Houston in the summer of 1979 and immediately became hooked, so to speak. As the story goes, that next fall, it was my night to physically lay out the pages of the student newspaper. I was the assistant sports editor of the *Daily Texan* at the University of Texas at Austin. A news release came to my attention from the athletic department, advertising a campus-wide "audition" for the first "voice of the Lady Longhorns." The nationally ranked women's basketball program was going to broadcast games on the radio for the first time. I decided it might be fun to try and gave it a shot. Guess who won the audition?

From that point forward, radio has been a true passion of mine. I did veer into television, and I also continue to regularly write stories and columns for a digital news outlet, but radio has long held me captive from the sheer power of sound. I can only imagine what it must have been like in radio's infancy, with families gathered around the big box in the parlor, listening to President Roosevelt's fireside chats, radio dramas, sports events, and more. If I lived a previous life, it surely was in radio's infancy, and I have long pictured myself creating visuals for those who cannot see but who are spellbound by the sounds coming from inside a box or within an automobile's dashboard.

I initially became captivated as a young boy listening to St. Louis Cardinals baseball on KMOX in St. Louis on my grandfather's old Civil Defense radio set. Jack Buck's voice hypnotized and fascinated me with his diction and description of the play in front of him, and somehow I always knew that I wanted to follow suit. After college, television paid the bills, but I always stayed connected to radio through fill-ins on talk shows, and eventually, as a 23-year-old, I received a huge break by getting a job in the NBA. When I arrived in Rhode Island from working in television in San Antonio, Texas, in 1988, it was initially for television purposes. But there was radio, waiting for me again, like a long-lost girlfriend.

And I ran to her.

The opportunity to become the "voice of the Providence Friars" presented itself to me after less than a year in the Ocean State, and I am so very grateful to Ron St. Pierre and Mitch Dolan for recognizing my passion and giving me a job that has helped define me as a professional—and as a person. Friar fans share my passion for sports, but they also share my passion for the pride that Rhode Islanders hold for their state. And much of that pride comes from the stories told by the voices "in the box," like Salty Brine, Sherm Strickhouser, Chris Clark, and Charlie Jefferds. The first voice I ever heard on Rhode Island radio was Jefferds's, and I was immediately impressed with his deep voice and his smooth, professional delivery. Charlie, like so many others I have come across, is a big-time, big-league pro. I am proud to have known each of these gentlemen, and I hope I can continue to serve their legacies well.

The following pages are meant to be a snapshot of the radio industry in Rhode Island through its 90-year history, and I only wish that it could be more thorough. There were many people and radio stations, both currently on the air and off, who were contacted but with whom we never connected. But I am so pleased to have gotten the response I did, and I hope you will remember some of the good old days gone by—like waking up to the "station that reaches the beaches"—and that you will fondly recall the many other notable radio professionals, radio stations, and voices that have helped to shape all of our lives . . . for the better.

One

THE DEPARTMENT STORE WARS

The broadcasting industry in the Ocean State was launched on June 5, 1922, when radio station WEAN signed on in Providence. Through more than 10 decades of people, places, personalities, and promotions, in different formats and listening structures, and in varying degrees of economic sense (as well as cents), radio continues to hold Rhode Island listeners close at hand, if not close at heart.

Actually, the beginning of radio in Rhode Island was not quite as magical or romantic as that might sound. In fact, radio broadcasting was born out of a sheer competitive desire to sell the new radio technology, as well as sell new suits, household goods, and more, to a consuming public in the early 1920s. The department store wars actually started it all.

The enormously successful Shepard's Department Stores opened in Boston and in Providence in the late 19th century. The Providence store actually began operations in 1880, in a small building on the corner of Westminster and Clemence Streets. Under the guidance of John Shepard III and Robert F. Shepard, grandsons of the store's founder, Shepard's quickly established itself as a major retail establishment. Seemingly content with the family business into the 1920s, the brothers were looking for a way to boost profits as well as gain a competitive advantage over fellow retailers Outlet, Gladding's, Cherry & Webb, Diamond's, and The Boston Store. It was John Shepard who first became enamored with the new radio technology of the time, and it was John who first realized what might be possible in the future.

The Outlet Company was Shepard's biggest rival. Fearing that the competition could get the jump on them, John and Robert both believed that customers would be drawn to their stores if they not only sold radio sets (unassembled as well as preassembled) but also originated radio programming from their stores. Fans and listeners did come to see these "voices in the box," and on their way through to the back of the store, they browsed through the merchandise as well.

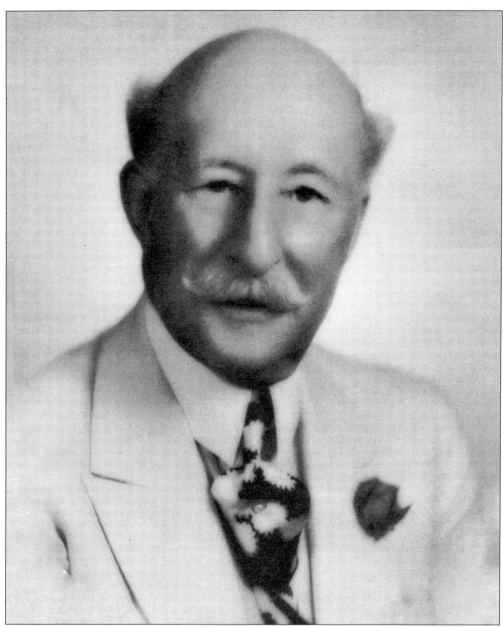

John Shepard Jr. was the founder and owner of The Shepard Company in Providence and of the Crown Hotel, which housed the first WEAN studios. His father, John Sr., started the Shepard-Norwell retail store (with partner Harvey Norwell) in Boston in the mid-1800s. But it was Shepard Jr. who developed the Boston store into a very popular retail outlet in the 1870s, and his son John III eventually joined the family business with his brother Robert. Shepard Jr. had built a department store empire throughout New England and recognized the potential of radio enough to publicize himself and his stores by financing his son's ventures. It was Shepard Jr., however, who served as the inspiration for the beginnings of the Yankee Network and who started it all in Rhode Island with his successful downtown Providence department store. (Courtesy National Radio Personalities, Solari, Boston.)

The grandsons of John Shepard Sr.—John III (at right) and Robert F. Shepard (below)—are directly responsible for launching radio in Rhode Island. It was John's idea to use radio to boost his stores' bottom line, but it was Robert who actually put WEAN on the air in Providence— about a month before John launched WNAC in Boston. Robert also held several other notable positions, including chairman of the Rhode Island State Planning Board, member of the Providence Housing Authority and of Rhode Island World's Fair Commission, and chairman of the Commercial and Financial Division of the Providence Community Fund. In 1922, a 36-year-old John III was assisting his father at the original Shepard's Boston store while Robert, 31, had recently taken over the Providence operation. Robert attended Yale, served in World War I, and, by all accounts, was content in the family endeavor. Older brother John prospered in retail life as well, but he was drawn to something else—a sort of new modern frontier. (Courtesy National Radio Personalities, Joseph Marcello.)

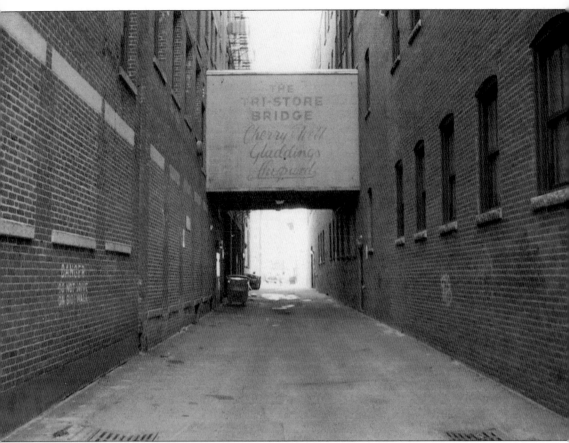

The department stores are long gone, but the "Tri-Store Bridge," built just before 1900, is still a landmark in an alleyway off Clemence Street in downtown Providence. The old bridge connected Cherry & Webb, Gladdings, and Shepard's Department Stores and originally allowed shoppers to move from store to store without having to step outside in the cold, snow, rain, or mud. It was a marketing idea that may have proven to be years ahead of its time. Gladdings was the oldest of the three stores, starting in Providence in 1766 under a different name and originally located on what is now North Main Street. It moved to the location near the bridge site in 1891, declared bankruptcy in 1972, and the building is now used by Johnson & Wales University. Shepard's opened in this location in 1880 (Westminster and Clemence), and Cherry & Webb was founded in 1888. (Courtesy Jef Nickerson.)

The Shepard's clock was a very popular, iconic spot for generations of Rhode Islanders to meet each other, dating back to 1880. The clock is what remains today of the vaunted Shepard's Department Stores on Westminster Street and is still a significant landmark in downtown Providence today. Lyrics from a Billy Mitchell song entitled "Meet Me Under the Shepard's Clock" include the following: "Meet me under the Shepard's clock, West-minster Street / Swell day for a city stroll, got happy feet / Takin' in a talkie at the Albee or Fay's, catchin' nine innings of the Providence Grays / Countin' every second till I see you again, ain't she sweet." In 1995, the University of Rhode Island converted the building into its continuing education complex and office space. (Right, courtesy John Henkel; below, courtesy William L. Bird.)

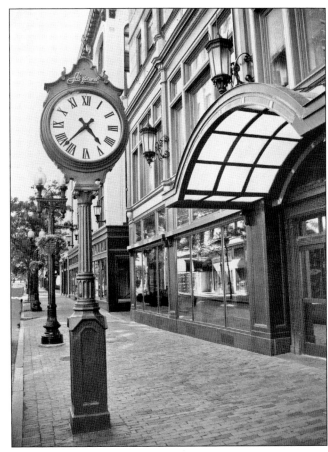

The (RKO) E.F. Albee Theatre, which opened in April 1919, three years before radio existed in the state, was a tremendous movie palace in Providence. Loew's State (now the Providence Performing Arts Center) was another grand theater that opened during radio's infancy in Rhode Island. The Albee was the site of many live radio shows and broadcasts during the era. In this 1932 service staff photograph can be seen Ed Pearson (second row, third from right). (Courtesy Marie Louise Pearson; photograph by Farley.)

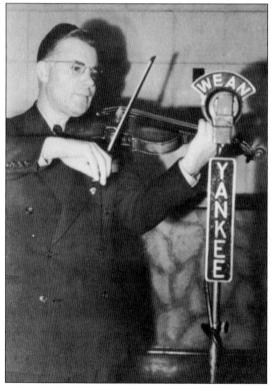

WEAN served as the flagship (primarily through the influences of the Shepard brothers, along with WNAC in Boston) for the Yankee Network, a regional radio service feeding newscasts and other programs throughout the region. WEAN was an affiliate of the Colonial Network as well, and while the Yankee Network included news and weather reporting services—which proved vital in the aftermath of the Great Hurricane of 1938—the Colonial Network was mostly educational and music programming. WEAN was the first station in Rhode Island back on the air after the 1938 storm, hanging a microphone out of a window on the second floor at the Crown Hotel in Providence and reporting on the desolation and destruction below. Those reports, carried on WNAC in Boston through the Yankee Network, helped immensely in the early stages of the recovery. In the early 1950s, WEAN was sold to the *Providence Journal-Bulletin*. (Courtesy National Radio Personalities, Joseph Marcello.)

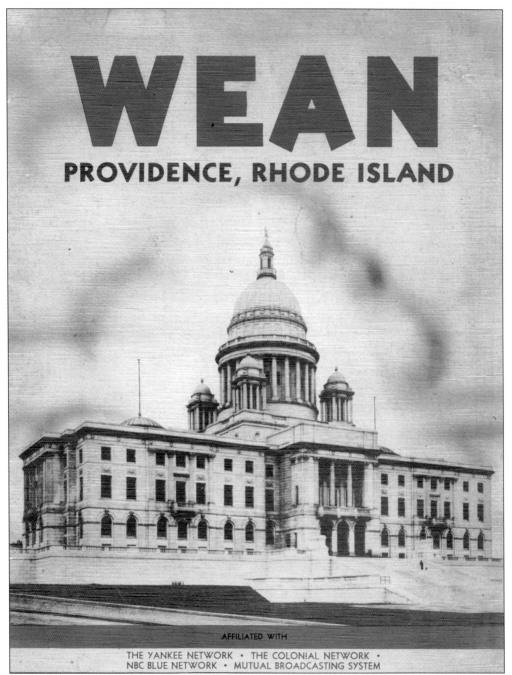

WEAN

PROVIDENCE, RHODE ISLAND

AFFILIATED WITH
THE YANKEE NETWORK • THE COLONIAL NETWORK •
NBC BLUE NETWORK • MUTUAL BROADCASTING SYSTEM

As a promotional item, WEAN showcased itself in book form with photographs and stories about its personalities and station personnel, published by National Radio Personalities in 1940. The book trumpeted Rhode Island's first radio station, touted the sharing of programming via the Yankee Network, and lauded its membership affiliations with the Colonial Network, NBC Blue Network, and the Mutual Broadcasting System. The original broadcast frequency was at 833 kHz, then moved up and down the dial—1100, 1110, 940, and 1090—before settling on 790. (Courtesy National Radio Personalities.)

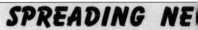

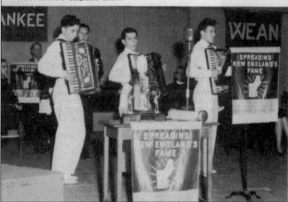

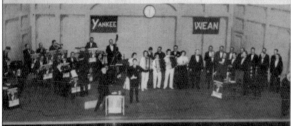

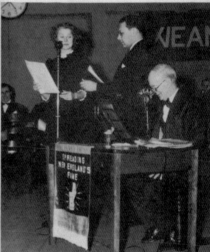

The marquee of the Metropolitan Theatre in Providence on the evening of the inaugural broadcast of "Spreading New England's Fame".

Major George Williams of the Salvation Army leads the first theme-singing in the first minutes of the first radio broadcast of "Spreading New England's Fame", which originated in Providence over WEAN, and was carried to the whole Yankee Network.

The Accordion Trio of (left to right) Edward Saccoccia, Tulio Gasparini and Louis Apparetti, played on the WEAN-Inauguration of this All-New England show.

Billy B. Van, master showman and trouper e his own glory the well-deserved title of New I city to city, discovers home talent, puts it on as part of the circus. The premiere performa of the Metropolitan Theatre, Providence, befor There's informality and a "homey" atmospher performances that make them worthy vehicles

At the microphone for an interview are Bernice Rile and Mowry Lowe, while "emcee" Billy B. Va chuckles at the table while introducing them.

Mayor John F. Collins receives the scroll certifyin pride in New England, presented to the City of Prov dence by The Yankee Network, WEAN and the me chants making the program possible. Mowry Low displays the certificate as Billy B. Van reads th presentation.

As a way to bring entertainment to the listening audience, and perhaps to bring that audience into their department store, WEAN was way ahead of its time in the 1930s and early 1940s. Its presentation of *Spreading New England's Fame* was a local precursor of today's *American Idol*. The radio show featured local and regional musicians, actors, and actresses. As a traveling show

NGLAND'S FAME

r . . . lo these many years . . . now adds to
assador of Good Will. His show travels from
uragingly, and presents the Mayor of each city
over WEAN, by remote control from the stage
dience that occupied every seat in the theatre.
shows, coupled with amazingly good musical
ading New England's Fame".

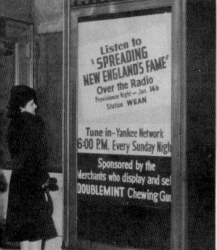

Announcing the introduction of a new program ex-
pressing the pride of New England — spreading its
ame.

Doris Skipp, soprano, revealed a marvelous voice and
echnique as she entertained the visible and radio
udiences with operatic and classical arias.

Charm had its place on our first program, too, as Bernice Riley took
the "mike" for her songs and piano patter on the stage of the
Metropolitan Theatre.

Further representation of Providence talent was proffered by the
capable Providence "Y" Singers, led by William Deroin, standing
at extreme left.

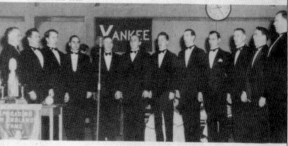

Joseph Cavanaugh, violinist, accompanied at the piano by Father
Leo Connon, presented still another manner of artistry with classi-
cal interpretations.

throughout the region, it stopped to play at the Metropolitan Theatre in Providence and also
broadcast live on WEAN and the Yankee Network. (Courtesy National Radio Personalities,
Joseph Marcello.)

LOCAL PROGRAMS

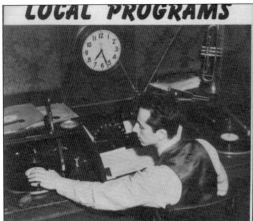

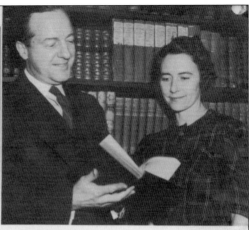

"Time, Rhyme and Rhythm"
. . . Jim Zerga directs a program of transcriptions of name bands, plus poetry and birthday greetings in a light, humorous vein.

"Readers' Guide"
. . . Alice McGrath and Clarence E. Sherman, librarians, talk about new books . . . and answer questions about books ancient and modern.

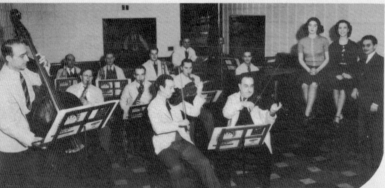

"The Rhode Islanders"—Left
. . . Carl Tatz, Director. L e o n a Smith and Connie Calderone, vocalists. Carl Tatz's orchestra furnishes a great variety of music of immense popular a p p e a l. This gifted musician, Carl Tatz, has played in every kind of theatre . . . vaudeville . . . legitimate . . . burlesque and opera.

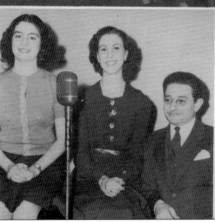

Left — **Carl Tatz** . . . Leona Smith a n d Connie Calderone.

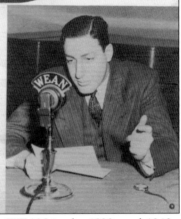

Fred Friendly's Program — "Footprints On The Sands of Time" . . . consists of brief biographical sketches of famous people. Over five hundred of t h e s e have been broadcast to date.

Local programming was quite varied—and interesting—on WEAN in the 1930s and 1940s. Fred Friendly's *Footprints on the Sands of Time* biographies of famous people served as a forerunner for several subsequent CBS radio and television broadcasts. In addition, live music and live readings—even shopping news—were all immensely popular. (Courtesy National Radio Personalities, Joseph Marcello.)

LOCAL PROGRAMS

Mayor **John F. Collins,** of Providence, Rhode Island — broadcasting, via the facilities of WEAN, by remote control, from his own office.

Governor **William H. Vanderbilt,** Chief Executive of the State of Rhode Island — does not overlook the power of radio broadcasting. Here you see the governor delivering a message over WEAN, by remote control, direct from his office.

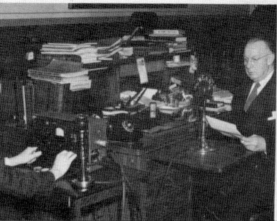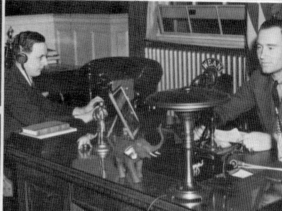

As one might imagine, Rhode Island politicians soon learned of the power, and reach, that radio provided. Providence mayor John Collins and Rhode Island governor William Vanderbilt both broadcast programs from their offices at city hall and the state house, respectively, taking full advantage of reaching the majority of their constituents with weekly, and sometimes daily, updates. (Courtesy National Radio Personalities, Joseph Marcello.)

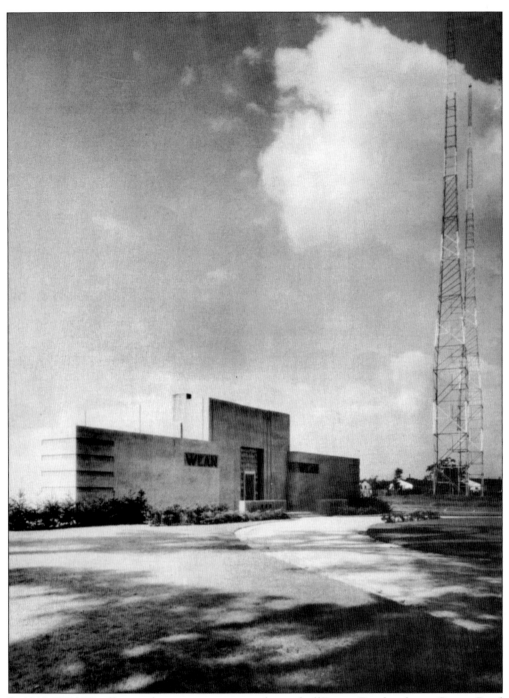

In 1940, WEAN's offices and transmitter site were located off Dexter Road and near Omega Pond in East Providence. At the time of the United States' entry into World War II, there were four radio stations in all of Rhode Island: WFCI (1420, Pawtucket) had just signed on in February; WEAN, an NBC Blue Network (today ABC) affiliate on 790, owned by the Shepard's stores; WJAR, an NBC Red Network affiliate on 920, owned by The Outlet Company; and WPRO, Cherry & Webb's CBS affiliate on 630 kHz. (Courtesy National Radio Personalities, Joseph Marcello.)

Two

RHODE ISLAND'S
EARLY DAYS

With a rather brilliant stroke of marketing expertise, the Shepard brothers obtained a commercial license to broadcast with the idea that this would allow them the ability to also advertise their merchandise and leverage a huge advantage over Outlet and their other competitors. Both John and Robert applied for licenses through the Department of Commerce, which regulated radio broadcasting at that time. As it happened, Robert (who ran the Providence store) was granted a license first, and he launched WEAN on June 5, 1922—about a month before John signed on with WNAC in Boston.

Fearing a huge competitive disadvantage, two months later, brothers John and Leon Samuels of the rival Outlet Company launched WJAR—which happened to be located about a block away from the Shepard's store in downtown Providence. By 1931, Cherry & Webb had purchased WPRO (formerly under the call letters WKBF in 1924, WDWF in 1925, and WLSI in 1927), becoming the third Rhode Island department store to own a radio station.

But the Shepard brothers had cast the first stone, and they both soon became broadcast industry leaders. In 1923, John became the first elected vice president of the National Association of Broadcasters. By 1930, WEAN and WNAC in Boston shared programming, thus creating the first "network" of its kind—the Yankee Network. The Yankee News Service was created by John Shepard in 1934 out of his frustration over Congress limiting radio stations (including his own) to just two news broadcasts per day. The fight for equal access within the media, the same access as that enjoyed by newspaper reporters, had begun. The war was on. And it rages still.

Ed Pearson (left) was frequently out on remote for WPRO in the 1930s. In this photograph, Majestic Theater owner Edward Fay is at the right. Prior to his stage days and his work for WOR Radio in New York City, Pearson began his broadcasting career at WPRO. After returning to Providence in the 1940s, he began the career many remember him for at WEAN and WPJB. (Courtesy Marie Louise Pearson.)

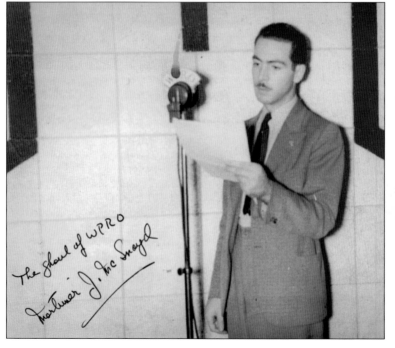

Mort Blender, a longtime news personality for WPRO-AM/FM/TV, is seen here performing in a radio drama as "The Ghoul of WPRO" in the late 1930s. Blender was later a popular news anchor and reporter for WPRO-TV (now WPRI) as well as on the radio side for many years. WPRO broadcast from studios located at 24 Mason Street. (Courtesy Marie Louise Pearson.)

This was the view down Weybosset Street in Providence, around 1950. Time-lapse photography reveals that the street was not terribly busy on this night. The Outlet Department Store, former home for WJAR Radio, is on the left, as is the Loew's State Theater. The Loew's movie palace is now the Providence Performing Arts Center. (Courtesy Marie Louise Pearson.)

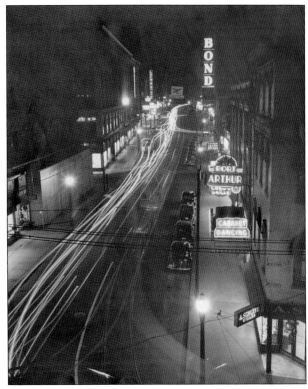

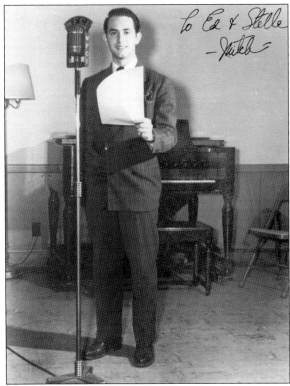

At the microphone, an announcer ("Mitch") for WFCI in Pawtucket in the late 1930s signed this photograph for Ed and Estelle Pearson. WFCI was one of four pre–World War II stations in the Providence market (along with WEAN, WPRO, and WJAR) first broadcasting at 1330 kc and later moving to 1420 kHz. WFCI launched an FM station at 101.5 around 1950 (now WWBB). Its first studios were located at 450 Main Street in Pawtucket. (Courtesy Marie Louise Pearson.)

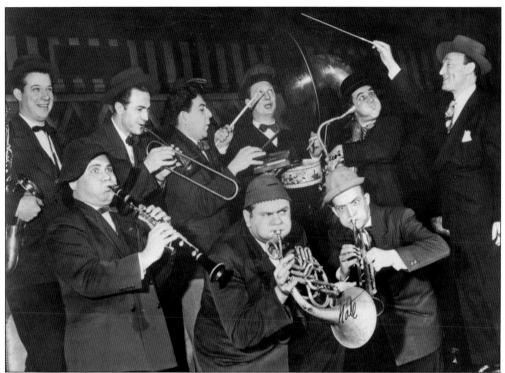

Live bands performing on the radio were commonplace in the early days, and one of the favorites was Al Trace and the Silly Symphonists. Trace, at far right, was a songwriter and orchestra leader who became popular during the big band era, thanks in part to songs like "Mairzy Doats." (Courtesy Marie Louise Pearson.)

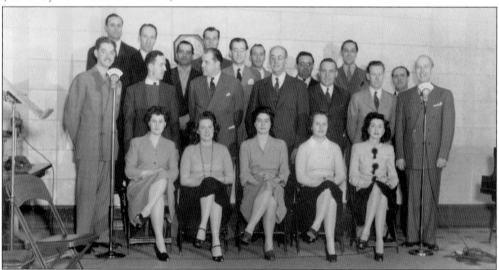

The "station that reaches the beaches" obviously had a much different look, and sound, in the early 1940s. Pictured here is the WPRO "house band" and some of the staff members, including Mort Blender (second row, left) and Ed Pearson (second row, right). In the first row, at the right, is Pearson's wife, the former Estelle Sevigny, who also worked for a time at WFCI and WPRO. (Courtesy Marie Louise Pearson.)

Ed Pearson's *Open House* on WPJB was very much an "open house" when it came to the show's content. Whether out on location, spinning records, interviewing celebrities, or talking to the public, Pearson was very much a man-about-town throughout Rhode Island. (Courtesy Marie Louise Pearson, from Roger Williams Photography.)

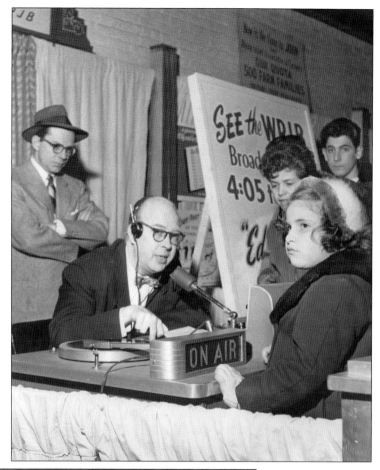

Ed Pearson (left) is shown here in an on-air bit with Rhode Island actors Eddie Dowling and Ruth Hussey on October 18, 1948. Both Dowling (actor, stage producer from Woonsocket) and Hussey (actress from Providence) are listed among the Top 50 Famous Rhode Islanders (50states.com). (Courtesy Marie Louise Pearson.)

25

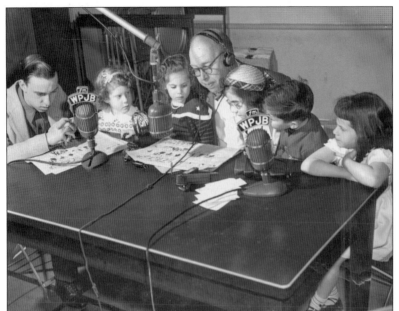

One of the staples of Ed Pearson's broadcast routine was his reading the comics with children—and to children—on Sunday mornings. The broadcast shown here occurred on April 5, 1949, on WPJB and included his daughter Marie Louise (second from left). (Courtesy Marie Louise Pearson.)

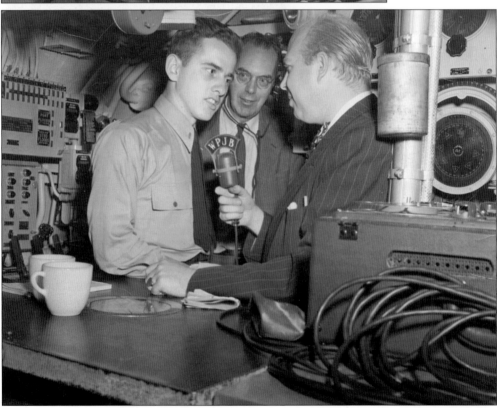

There wasn't a spot from which Ed Pearson wouldn't broadcast. In this c. 1950 photograph, Pearson is doing a live broadcast on WPJB-FM from a submarine, in the era after World War II and prior to the Korean War. Pearson was definitely a fan of the military, and the feeling was mutual. (Courtesy Marie Louise Pearson.)

This is a profile/promotional photograph of a younger Ed Pearson behind the mic for CBS–affiliated WPRO during the 1940s. Note the cigarette in his left hand. Smoking in the studio was commonplace at the time, well in advance of present-day indoor smoking restrictions. (Courtesy Marie Louise Pearson.)

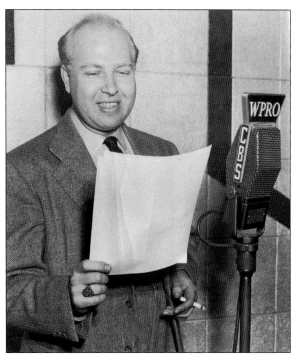

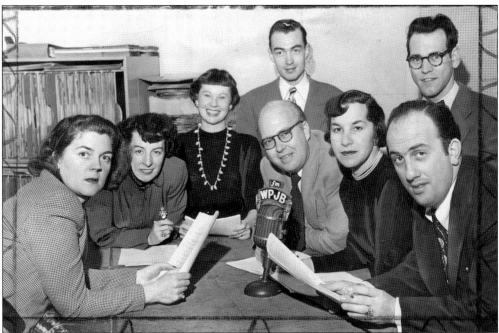

Shown here is the new team at the all-new WPJB-FM. Licensed to broadcast in 1948, the Providence Journal Company launched WPJB at 105.1 in July 1948, with their original studios located on the fourth floor of their building at 75 Fountain Street in Providence. Among those shown here are Ed Pearson (seated, center), his on-air partner Ray Sjoberg (standing behind Pearson), and Carl Henry (seated, right), with cigarette in hand. (Courtesy Marie Louise Pearson, from Joseph Arsenault.)

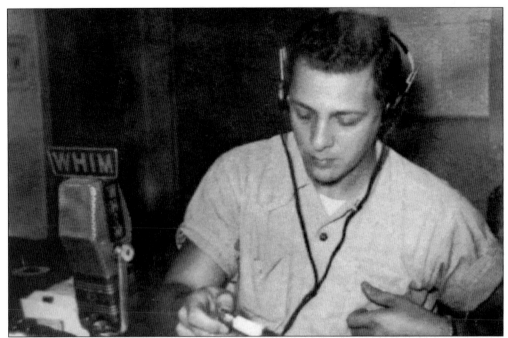

Paul Garnett is seen here in the studio of WHIM-AM 1110, just after the station signed on in April 1947. From 1958 to 1966, WHIM was a Top 40 station competing with WPRO-AM 630 and WICE-AM 1290. It had an FM sister station, WHIM-FM, at 99.9, licensed to Cranston, Rhode Island (according to the *Providence Journal Almanac, 1947–1960*). The FM later became WLOV and went dark. A new WHIM-FM emerged on 94.1. (Courtesy National Radio Personalities.)

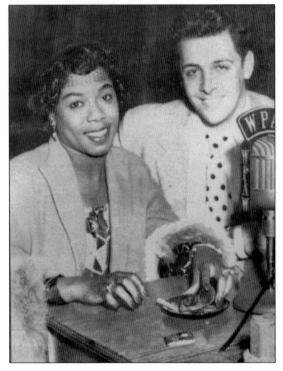

WPAW-AM went on the air in 1950 after being granted a license to operate originally at 1380 kc (during construction in 1948) in Pawtucket. Operating at 550 on the AM dial, WPAW later became WXTR in the 1960s and then WGNG. There were two incarnations of WPAW, the first one coming from the original WFCI in the 1930s. It later merged with WPRO. (Courtesy National Radio Personalities.)

This Certifies That

(Signature of Member)

Is a Member of

UNCLE EDDIE CLUB

WPJB
fm

And Listens
Regularly to
The Club
Broadcasts

Uncle Eddie

The Uncle Eddie Club was a promotional gimmick and marketing opportunity in the late 1940s and early 1950s to attract younger listeners—and their parents. *The Uncle Eddie Club* (WPJB-FM on Sundays) featured Ed Pearson reading the funny papers (comic pages) to kids, interviewing kids, playing music, and more. The above photograph shows a copy of an original club card from April 1949. (Above, courtesy Marie Louise Pearson; below, courtesy the *Providence Journal*.)

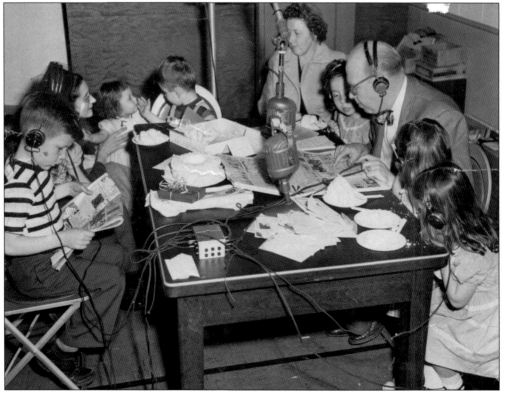

Bill Corsair, a native of Rumford, Rhode Island (East Providence), and pictured here with his wife, Janis, served as the public affairs director for WICE. He organized and directed public service campaigns for many groups and charitable organizations on what was then known as "The Mighty 1290—Your Station of the Stars." (Courtesy Bill Corsair.)

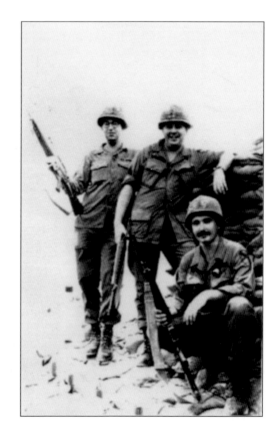

Bill Corsair hosted *The Coffee Club* on WICE 1290 on Thursdays from 9:00 a.m. to 12:00 noon, from what was then known as the Midland Mall in Warwick (now the Rhode Island Mall). After recording his voice for the first talking G.I. Joe action figures, Corsair's National Guard unit was called to serve in Vietnam, and he earned several honors, including the Bronze Star with Oak Leaf Cluster. Pictured here are, from left to right, SP5 Paul Nicholson, SSG Bill Corsair, and Sgt Ron Piatek serving with the 1st Cavalry Division in Phuc Vinh, Vietnam. (Courtesy Bill Corsair.)

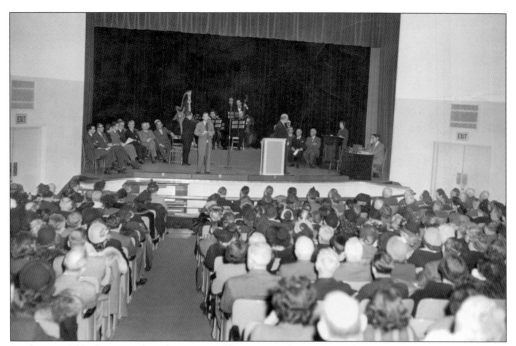

In this c. 1950 photograph, a live musical/variety performance is being aired on WPJB-FM at a local unidentified auditorium, with Ed Pearson hosting the radio broadcast. Pearson is seen at the podium. Live musical broadcasts were staples of the era in local radio, featuring local orchestras, bands, and vocalists. (Courtesy Marie Louise Pearson, *Providence Journal*.)

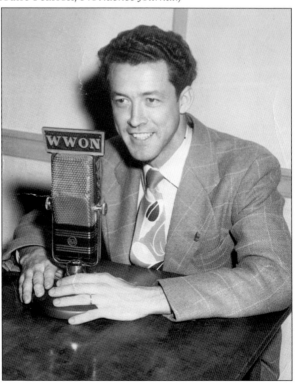

"Gentleman" Gene DeGraide's radio career spanned parts of five decades as a popular disc jockey and host in Rhode Island and included stints at WWON, WJAR, and WKRI along the way. Later a spokesman for the Tasca family and their automobile dealerships, DeGraide also hosted television programs on WJAR and WPRO/WPRI. DeGraide was inducted into the inaugural class of the Rhode Island Radio Hall of Fame in 2008. (Courtesy Gene DeGraide.)

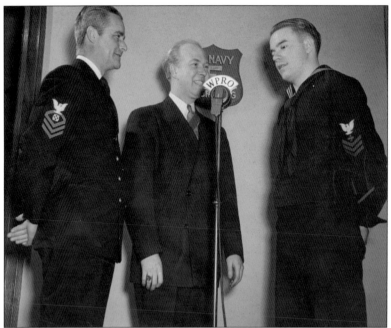

As a matter of public interest and public service, Ed Pearson conducted interviews with newly drafted and recently inducted military personnel as World War II began to pick up steam. Pearson is shown here on WPRO with a Naval officer and a recent recruit around 1940. (Courtesy Marie Louise Pearson, from Joseph Marcello.)

This episode of *Ed Pearson's Open House* might be titled "Beauty and the Beast." Pearson met and interviewed Evelyn Ay, Miss America of 1954, on his WPJB-FM afternoon show on June 30, 1954. (Courtesy Marie Louise Pearson, from Mr. Millard, PJB.)

In 1948, National Radio Personalities published a promotional book featuring the on-air staff of WHIM-AM 1110 in Providence. WHIM's studios were located in the Real Estate Title Building at 32 Custom House Street in downtown Providence. WHIM used the book not only to promote the successful AM station that launched on April 15, 1947, but to alert readers and listeners to the oncoming advance of FM radio. (Courtesy National Radio Personalities.)

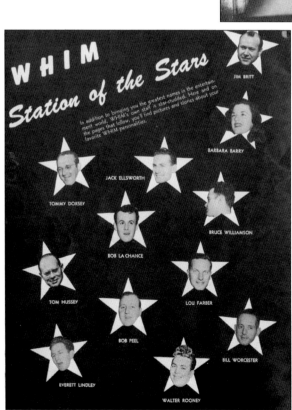

In 1948, WHIM ("Station of the Stars") played the recording stars of the day, to be certain. But it also played up its own all-star staff, featuring Jim Britt, Barbara Barry, Tommy Dorsey, Jack Ellsworth, Bruce Williamson, Bob LaChance, Tom Hussey, Bob Peel, Lou Farber, Everett Lindley, Walter Rooney, and Bill Worcester. (Courtesy National Radio Personalities.)

This photograph was taken in the 1950s on a rare occasion when all of these big names at the time were in one place together. At a fundraising event, the Rhode Island broadcasting icons shown are, from left to right, George Downey, WEAN; Don Rogers, WRIB; Ed Pearson, WEAN; Jim Mendes, WICE; Todd Williams, sales executive; Salty Brine, WPRO; Paul Richard, WPAW; Ernie Anderson, WHIM; and Gene DeGraide, WJAR. (Courtesy Gene DeGraide, *Down Memory Lane*.)

In the late 1950s, some true radio superstars met to break bread and pose for this photograph. Shown are, from left to right, (first row) Ed Pearson, Fred Grady, and Carl Henry; (second row) Gene DeGraide, George Downey, Ernie Anderson, and Jim Mendes. (Courtesy Gene DeGraide, *Down Memory Lane*.)

This original newspaper advertisement ("Will be on the air soon!") ran in the *Providence Journal-Bulletin* announcing the sign-on of WPJB-FM on July 11, 1948. The studios were located at 53 Mathewson Street in Providence, with the tower on Neutaconkanut Hill in Johnston. Among the 21 new staffers introduced were Ed Pearson, Ray Sjoberg, Roy Howard on sports, and station manager William Koster. The station was billed as "radio without interference from other stations—as natural as life." (Courtesy Marie Louise Pearson.)

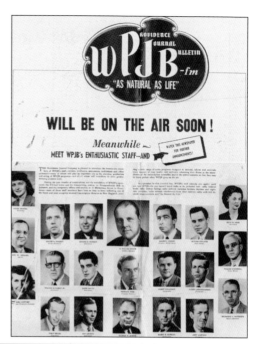

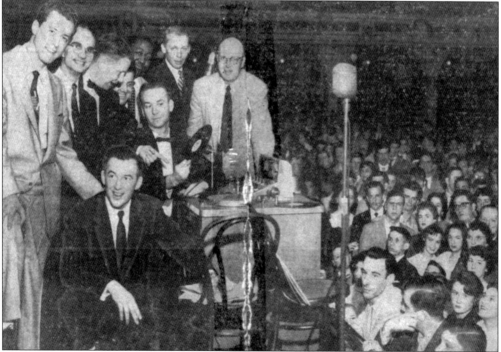

This fantastic photograph from the *Providence Journal-Bulletin* ran on January 30, 1954. It depicts the popular disc jockeys of the time spinning records for the March of Dimes at Rhodes on the Pawtuxet to a huge crowd. Pictured here are, from left to right, (kneeling) Ernie Anderson (WHIM); (seated) Salty Brine (WPRO); (standing) Gene DeGraide (WJAR), Grahame Richards (WPAW), Todd Williams (WEAN), Don Rogers (WRIB), Jim Mendes (WICE), George Downey (WEAN), and Ed Pearson (WPJB). (Courtesy Marie Louise Pearson, *Providence Journal-Bulletin*.)

While Ed Pearson was a part of WEAN/WPJB, the two stations often flip-flopped programs and time slots in order to maximize ratings and advertising potential. This advertisement was taken out in the *Providence Journal-Bulletin* in the 1950s, with Pearson switching to morning drive on WEAN. (Courtesy Marie Louise Pearson, *Providence Journal-Bulletin*.)

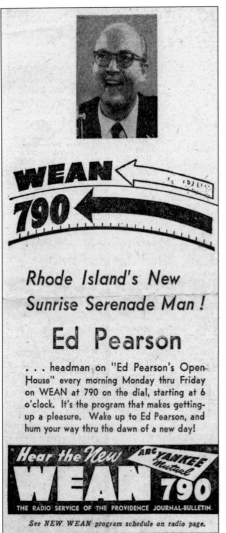

Rhode Island's New Sunrise Serenade Man!

Ed Pearson

. . . headman on "Ed Pearson's Open House" every morning Monday thru Friday on WEAN at 790 on the dial, starting at 6 o'clock. It's the program that makes getting-up a pleasure. Wake up to Ed Pearson, and hum your way thru the dawn of a new day!

Hear the New
WEAN 790
ABC YANKEE Mutual
THE RADIO SERVICE OF THE PROVIDENCE JOURNAL-BULLETIN

See NEW WEAN program schedule on radio page.

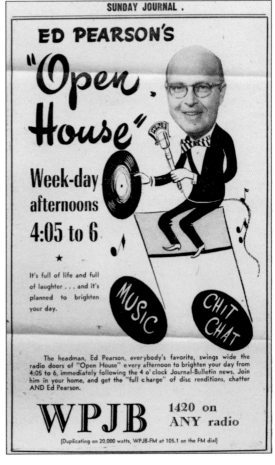

SUNDAY JOURNAL.

ED PEARSON'S "Open House"

Week-day afternoons 4:05 to 6

★

It's full of life and full of laughter . . . and it's planned to brighten your day.

MUSIC CHIT CHAT

The headman, Ed Pearson, everybody's favorite, swings wide the radio doors of "Open House" every afternoon to brighten your day from 4:05 to 6, immediately following the 4 o'clock Journal-Bulletin news. Join him in your home, and get the "full charge" of disc renditions, chatter AND Ed Pearson.

WPJB 1420 on ANY radio

(Duplicating on 20,000 watts, WPJB-FM at 105.1 on the FM dial)

Pearson heads back to WPJB, which was also simulcast for a while on 1420 AM, in addition to the 105.1 FM frequency. His *Open House* program moved back to afternoon drive time, as depicted in this newspaper advertisement. (Courtesy Marie Louise Pearson, *Providence Journal-Bulletin*.)

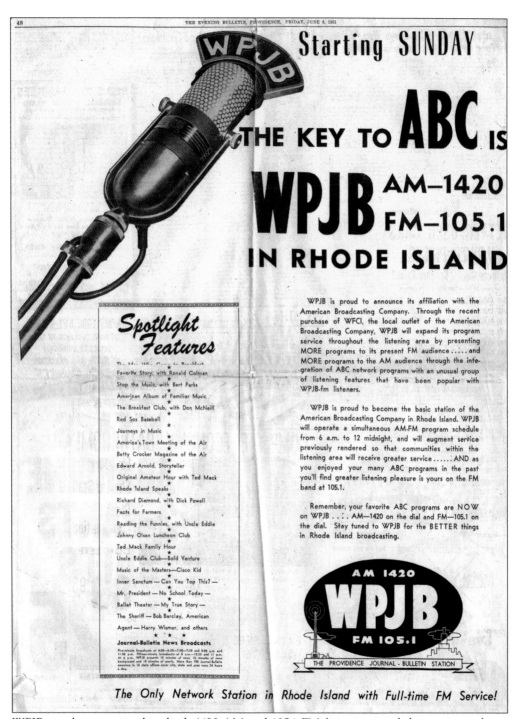

WPJB simulcast its signal on both 1420 AM and 105.1 FM for a time, and the station took out this full-page advertisement in the *Providence Journal-Bulletin* on June 8, 1951, to announce a full-time affiliation with ABC Radio. As the 1950s progressed, WPJB ended up moving much of its programming to WEAN and eventually sold the 1420 AM frequency. (Courtesy Marie Louise Pearson, *Providence Journal-Bulletin*.)

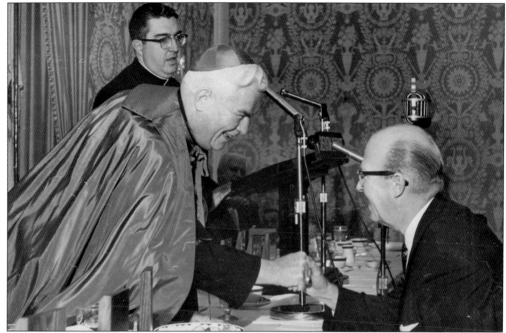

There is nothing like a blessing from the bishop to ensure a show's success. Ed Pearson (right) is seen here with Bishop Russell McVinney, who presided over the Diocese of Providence during the start of the baby boom era (post–World War II 1950s) and the growth of suburbs throughout Rhode Island. This broadcast on WPJB took place from the Sheraton Biltmore in downtown Providence. (Courtesy Marie Louise Pearson.)

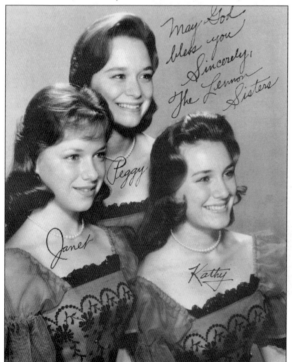

Ed Pearson interviewed many stars during his career. He received this autographed photograph from three of the four famous singing Lennon sisters, who made their debut on television's *Lawrence Welk Show* in 1955. The singers made a promotional radio stop in Providence in the early 1960s. From 1960 to 1964, the quartet was only three—Peggy, Janet, and Kathy, pictured here; the eldest, Dianne, got married and left the group and rejoined later. (Courtesy Marie Louise Pearson.)

Florence Parker Simister's *Streets of the City* program on WEAN received a citation from the Rhode Island Historical Society for its 1,000th broadcast on November 28, 1957. Like Florence Markoff's *Portraits in Sound* of the 1960s–1980s, *Streets of the City* showcased not only famous people and places in Providence, but also women radio broadcasters in Rhode Island history. (Courtesy Marie Louise Pearson, *Providence Journal-Bulletin*.)

Mrs. **Florence Parker Simister**, author of the WEAN-WPJB radio program, 'Streets of the City,' receives a citation from Clifford P. Monahan, director of the Rhode Island Historical Society honoring her for the 1,000th broadcast of the program. Others (l-r) are H. William Koster, manager of the stations; Ed Pearson, narrator of the program; Governor Roberts, Dr. Charles H. Ashworth, Physicians Service president, and Stanley H. Saunders, Blue Cross executive director. The two agencies are co-sponsors of the show.
—*Journal-Bulletin Photo*

'Streets of City' Wins Citations

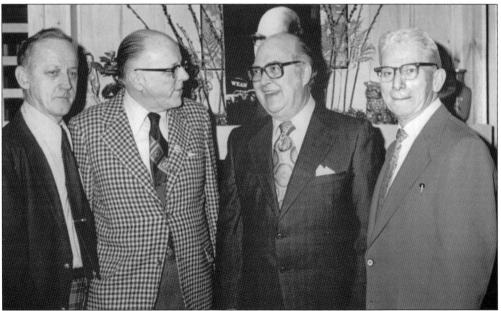

Ed Pearson retired from WPJB and WEAN in 1975 at the age of 62. At his retirement party, pictured here, Pearson closed the book on a 38-year career at the Great House in Warwick. Shown here are, from left to right, Jerry Lampinski, his longtime producer; H.W. Costa; Ed Pearson; and Robert Morgan, also a longtime producer and engineer. The four men worked as a team for 28 years in Rhode Island radio. (Courtesy Marie Louise Pearson, Henry Mathews.)

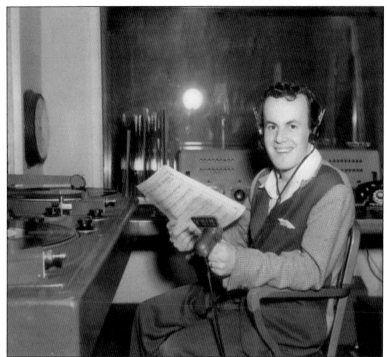

Bob LaChance is shown here "rehearsing" for the difficult job of "singing over records" on WHIM in 1948. Many of the early radio personalities would sing favorite songs over a background of music recorded by the country's finest orchestras. LaChance sang as a choirboy, studied in Boston and Providence, and was an Air Force pilot as well. (Courtesy DeGraide family.)

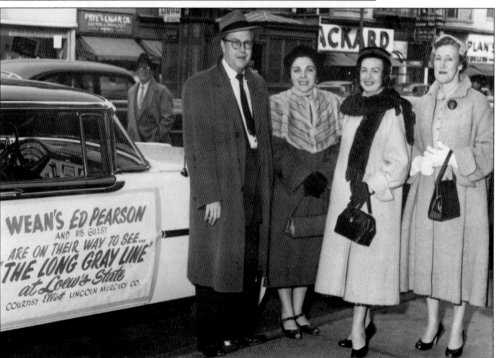

One thing WEAN's Ed Pearson did was get out in the public, and it undoubtedly contributed to his popularity, on and off the air. Pictured here in the early 1950s with his guests, Pearson frequently joined listeners for shows at the Loew's State Theater (now the Providence Performing Arts Center) in Providence. (Courtesy Marie Louise Pearson.)

WEAN's Ed Pearson frequently had the "stars of the day" on his programs, as they made appearances in and around Rhode Island. In the above photograph, he interviews Arthur Godfrey, one of the premier television personalities of the 1950s and a radio superstar who began his career in the 1920s. Godfrey, who passed away in 1983, was inducted into the National Radio Hall of Fame in 1988; Pearson was inducted into the Rhode Island Radio Hall of Fame in 2011. (Courtesy Marie Louise Pearson.)

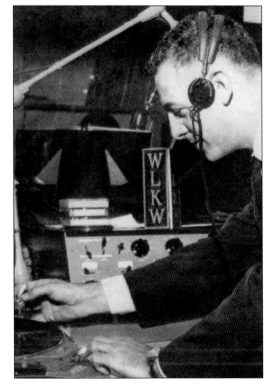

Paul Garnett, one of the "beautiful music" voices behind the classics on WLKW, is seen in this c. 1965 photograph. Currently assigned to the 1450 AM frequency, WLKW began broadcasting in April 1961 on 990 AM and has appeared up and down the dial at several frequencies, including 990, 550, 790, and 1450, and on the FM dial at 101.5. The call letters "LKW" stand for 50 kilowatts, "L" being the Roman numeral for 50. It was Rhode Island's first and only 50,000-watt station. (Courtesy National Radio Personalities.)

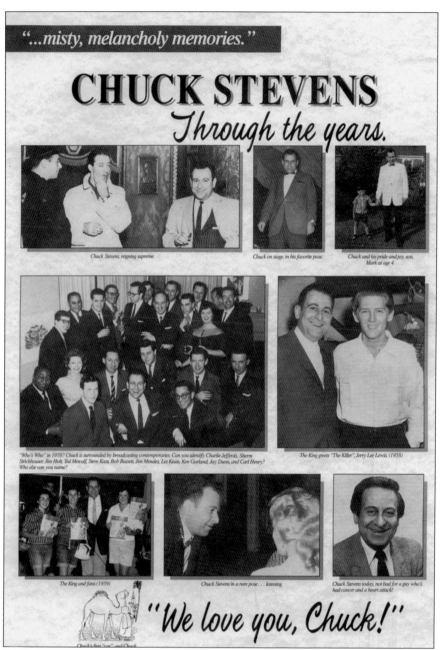

"...misty, melancholy memories."

CHUCK STEVENS
Through the years.

Chuck Stevens, reigning supreme.

Chuck on stage, in his favorite pose.

Chuck and his pride and joy, son, Mark at age 4.

"Who's Who" in 1958? Chuck is surrounded by broadcasting contemporaries. Can you identify Charlie Jefferds, Sherm Strickhouser, Jim Holt, Ted Metcalf, Steve Kass, Bob Bassett, Jim Mendes, Les Keats, Ken Garland, Jay Dunn, and Carl Henry? Who else can you name?

The King greets "The Killer", Jerry Lee Lewis. (1958)

The King and fans.(1959)

Chuck Stevens in a rare pose... listening.

Chuck Stevens today, not bad for a guy who's had cancer and a heart attack!

"We love you, Chuck!"

"Hello you" was Chuck Stevens's famous sign-on during a career that spanned parts of four decades. A pioneer disc jockey and popular personality on radio stations WRIB, WICE, WPAW, WXTR, and WGNG during the rock 'n' roll era of the 1950s and 1960s, Stevens also spent time in sales and promotions during his career. Inducted into the inaugural class of the Rhode Island Radio Hall of Fame in 2008, Stevens stood out at a time when Joe Thomas, Jim Mendes, Big Ange, and many others were established or just getting their careers started. The 1958 group photograph insert at left center includes Sherm Strickhouser, Charlie Jefferds, Steve Kass, Jim Mendes, Les Keats, Ken Garland, Jay Dunn, Carl Henry, Bob Bassett, Ted Metcalf, and Jim Holt. (Courtesy Mark Stevens.)

On Sunday afternoons at 12:30 p.m., Ed Pearson read the *Providence Journal-Bulletin* funny pages on WPJB to youngsters of all ages. And his popular *Open House* program on weekday afternoons was widely advertised, so that any time there was a frequency change, readers were alerted where to go. (Courtesy Marie Louise Pearson, *Providence Journal-Bulletin*.)

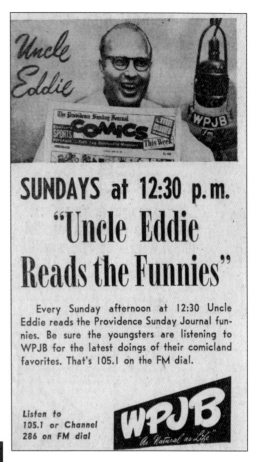

SUNDAYS at 12:30 p.m.
"Uncle Eddie Reads the Funnies"

Every Sunday afternoon at 12:30 Uncle Eddie reads the Providence Sunday Journal funnies. Be sure the youngsters are listening to WPJB for the latest doings of their comicland favorites. That's 105.1 on the FM dial.

Listen to
105.1 or Channel
286 on FM dial

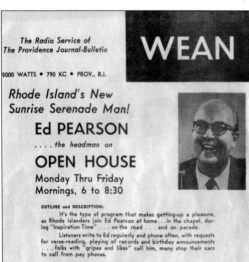

WEAN produced this flyer around 1957 for prospective advertisers describing the advantages of buying time on Ed Pearson's *Open House* program, when it was a part of morning drive on the station. (Courtesy Marie Louise Pearson.)

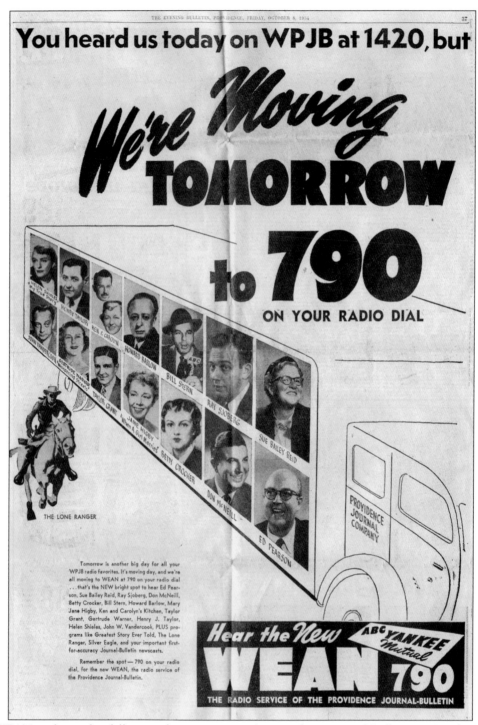

WEAN took out this full-page advertisement in the *Providence Journal-Bulletin* on October 8, 1954, informing listeners of their programming move, down the dial from WPJB 1420 AM to WEAN 790. The move was advertised to the public as the "new WEAN," the radio service of the *Providence Journal-Bulletin*. (Courtesy Marie Louise Pearson, *Providence Journal-Bulletin*.)

Three

FULL SERVICE AND SMALL-MARKET RADIO

Rhode Islanders are notorious for being set in their ways.

Now, that doesn't necessarily mean they can't change their minds, but rather, when they hear something they like, they keep listening. One of the wonderful quirks about the nature of Rhode Island "habits" might be the loyalty with which consumers stay with what's familiar to them. But in the current era of radio—from the late 1980s to the present time—familiarity has largely fallen by the wayside. Powerhouse stations like WPRO-AM/FM and WHJJ-AM and WHJY-FM are bought, sold, plundered, sold, and bought again. And the smaller guys? Somehow, they have managed to survive.

For lack of a better phrase, these "full service, community" stations continue to serve the individual, smaller communities in the state, and, with their loyal listening audience, continue to keep their neighbors entertained and informed. While many small-market stations around the country have survived by cutting staff and bringing in "canned" programming (via satellite), there are three stations of note in Rhode Island bucking the trend and remaining true to their roots—and to their communities.

In the Northwest/Blackstone Valley region of the state, listeners have been well-served for more than 60 years by WOON-AM (formerly WWON) and WNRI-AM. WWON signed on in 1946 as Woonsocket's first radio station, while WNRI (which has claimed to be the Blackstone Valley's most listened to station) began operations in 1954. From that time, and through changes in station ownership, one thing has remained constant—a "rivalry" between two small stations that has resulted in both continuing to serve their listeners with a healthy dose of "local."

Former longtime community stations like WKRI (West Warwick) have left the local airwaves altogether, and current local licenses WALE (Greenville), WARV (Warwick), WCRI (Block Island), WCVY (Coventry), and others continue to broadcast with various brokered formats. WBLQ, call letters once belonging to Block Island, now operates local news and variety programming on the former WERI in Westerly, where a former WBLQ disc jockey took over station operations in the late 1990s, hoping to better serve the local community.

In this photograph, Gene DeGraide, about to spin a Tommy Dorsey record, mans the controls for WWON-AM 1240 in Woonsocket. WWON signed on as the Blackstone Valley's first radio station on November 11, 1946. The call sign changed to the current WOON in 1992. Owned by the *Woonsocket Call* newspaper for a period of time, the station remains locally owned and operated today. (Courtesy Gene DeGraide.)

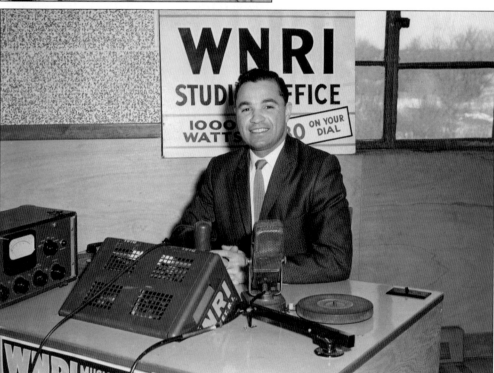

Joe Britt was the founder and first owner/general manager of WNRI 1380 in Woonsocket. Britt, whose given name is Joseph Britto, signed WNRI on the air on November 28, 1954, as the Blackstone Valley's second "full-service" radio station. (Courtesy Roger Bouchard.)

Shown here is a promotional flier for the holidays in December 1956, featuring "A New Dimension in Radio Entertainment, the New WNRI 138." Staff and on-air members included Joe Britt, Dick Bouchard, Dave Grady, Tom Koller, Barbara Coccoli, Jim Babiana, Phil Alarie, Joe Struzik, Agastinho DeMatos, Alfredo Silvario, Lillian Britt, and John Costa. (Courtesy Roger Bouchard.)

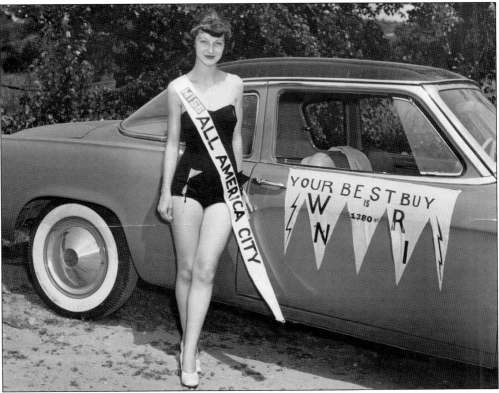

Who loves a parade? The residents of Woonsocket past certainly seemed to enjoy them. This photograph of the 1955 Woonsocket Mardi Gras parade shows the parade entry (in a Studebaker, no less) from WNRI Radio. Miss All America City queen Betty DeCesare graced the Studebaker with her presence. (Courtesy Roger Bouchard.)

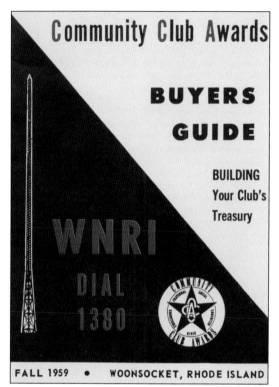

Community Club Award booklets were for listeners to support their local businesses with coupons and discounts to area merchants, a practice that continues to this day in many cities. This promotional buyer's guide is from the fall and spring of 1959. (Courtesy Roger Bouchard.)

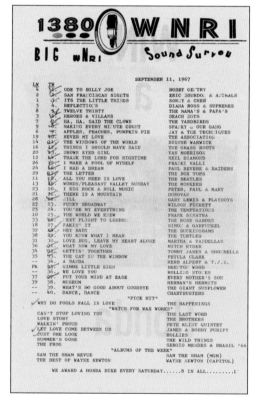

A 1380 WNRI playlist "Sound Survey" from September 11, 1967, shows "Ode to Billy Joe" by Bobby Gentry at the top. Notice the check marks that were made as the songs were played—perhaps an early traffic system! (Courtesy Roger Bouchard.)

Coffee An'—one of the longest running panel discussion programs in American radio—has been a staple of morning programming on WOON since the station's sign-on as WWON, the Blackstone Valley's first station, in 1946. *Woonsocket Call* publisher Andy Palmer received an honorary Fire Chief award in 1972 from Chief Gerald Landry (right) and Deputy Chief Gene Prochianak (left). (Courtesy Dave Richards, Dave Russell.)

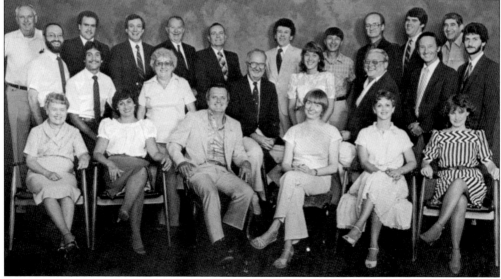

This is a promotional staff photograph of, at the time, WWON (now WOON) in Woonsocket, September 1983. The FM signal at 106.3 is now WWKX and is owned by Cumulus. Among those shown in the photograph are longtime personality and station manager Dave Russell (first row, third from left); Mike Montecalvo, now at WPRI-TV (second row, second from left); Vin Ciavatta, also known as Vin E. McCoy (second row, right); and current station manager Dave Richards (third row, third from left). (Courtesy Vin Ciavatta.)

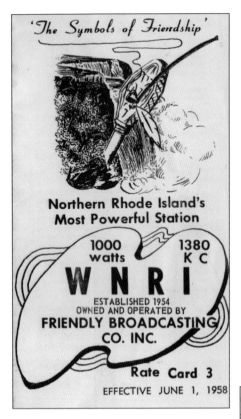

'The Symbols of Friendship'

Northern Rhode Island's
Most Powerful Station

1000
watts

1380
K C

WNRI

ESTABLISHED 1954
OWNED AND OPERATED BY
FRIENDLY BROADCASTING
CO. INC.

Rate Card 3
EFFECTIVE JUNE 1, 1958

Was this an advertisers' delight? This is an early rate card from WNRI, effective June 1, 1958, billing itself at the time as "Northern Rhode Island's Most Powerful Station." Broadcasting from 6:00 am to sunset, a single 30-second spot could be had for just $3. (Courtesy Roger Bouchard.)

WNRI took out an advertisement in the *Woonsocket Call* on November 30, 1957, to announce their December 1 move to new studios located at 786 Diamond Hill Road. The station is still located at that address today. (Courtesy Roger Bouchard.)

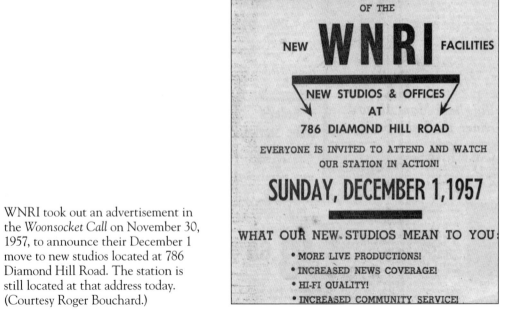

BEGINNING OUR 4th YEAR OF BROADCASTING!

ANNOUNCING... 4/30/57

THE

GRAND OPENING

OF THE

NEW WNRI FACILITIES

NEW STUDIOS & OFFICES
AT
786 DIAMOND HILL ROAD

EVERYONE IS INVITED TO ATTEND AND WATCH
OUR STATION IN ACTION!

SUNDAY, DECEMBER 1, 1957

WHAT OUR NEW STUDIOS MEAN TO YOU:

• MORE LIVE PRODUCTIONS!
• INCREASED NEWS COVERAGE!
• HI-FI QUALITY!
• INCREASED COMMUNITY SERVICE!

Included on the reverse side of this 1967 playlist was a promotion to "Win a Honda" from WNRI. The Honda motorcycle was sitting on top of the WNRI "mobile news vehicle," which, at the time, was a Volkswagen bus. (Courtesy Roger Bouchard.)

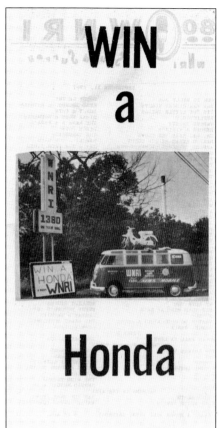

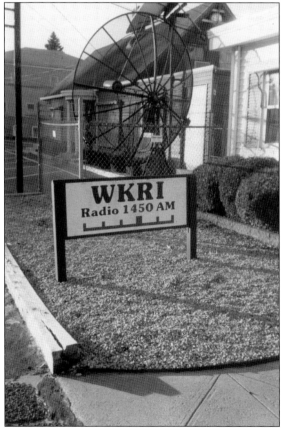

This photograph shows the front view of the satellite dish and studio building for WKRI in West Warwick. The 1450 AM frequency call letters are currently WLKW, as of May 2012, but the frequency was the longtime home for WWRI and WKRI, both serving the West Warwick area. WWRI launched in August 1956, became WSVP in 1969, and changed to WKRI in 1973, until 1995. (Courtesy Roger Bouchard.)

Dave Richards (left), an inductee into the Rhode Island Radio Hall of Fame and a longtime employee and current owner/operator of WOON-AM 1240 Woonsocket, poses with former Red Sox radio voice Ken Coleman at McCoy Stadium in Pawtucket. WOON, formerly WWON, has been a longtime affiliate of the Pawsox Radio Network. (Courtesy Dave Richards.)

Congratulations

Upon

Opening Of New Studio

WOON AM

19 SEPTEMBER 2008

Best Wishes

Robert H. Larder, Esquire

Once upon a time, WWON was not just an AM signal at 1240, but also the FM signal at 106.3 now belonging to WWKX. WOON moved its studios from the window-front location on Social Street to their present location on Park Avenue in Woonsocket. (Courtesy Dave Richards.)

This 1970s photograph is looking out from across the street on Diamond Hill Road in Woonsocket at the front door and parking lot for the WNRI 1380 studios. Prior to the station sign-on in 1954, the call letters were assigned to a shortwave station located in New Jersey, utilized primarily by the government during World War II. (Courtesy Roger Bouchard.)

The famous Stadium Theater in Woonsocket hosted all kinds of shows for all kinds of audiences—and still does. Here, the marquee in the mid-1970s announced WNRI Night, with Frankie Vee and the Lil' Ole Opry. (Courtesy Roger Bouchard.)

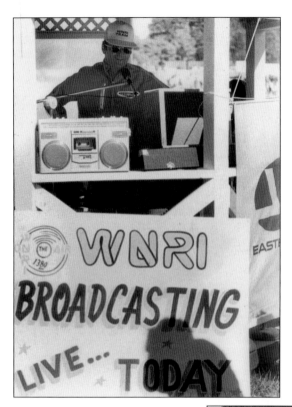

Dick Bouchard is shown here on remote doing what WNRI does best: getting out in the community, in this case broadcasting live from the annual Autumnfest celebration in 1984. Note the boom box. Whoever said community radio couldn't be hip? (Courtesy Roger Bouchard.)

This advertisement, "Enjoy Autumnfest 11 with 1380-WNRI," ran in the *Woonsocket Call* in 1987 and featured the station's on-air personnel at the time, along with prizes and giveaways. Autumnfest's tradition in Woonsocket began in 1977 over Columbus Day weekend. (Courtesy Roger Bouchard, *Woonsocket Call.*)

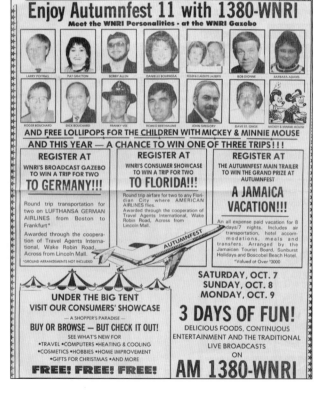

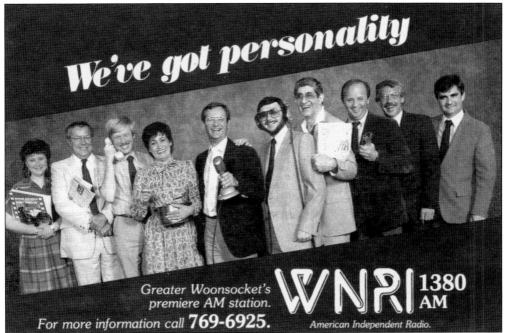

Shown here is a late 1980s WNRI promotional photograph ("We've Got Personality") for "Greater Woonsocket's premiere AM station." Shown here are, from left to right, unidentified, Frank Viscatis, Larry Poitras, Pat Gratton, Roger Bouchard, Bob Allen, Joe Hyder, Dick Bouchard, Dave St. Onge, and Romeo Berthiaume. (Courtesy Roger Bouchard.)

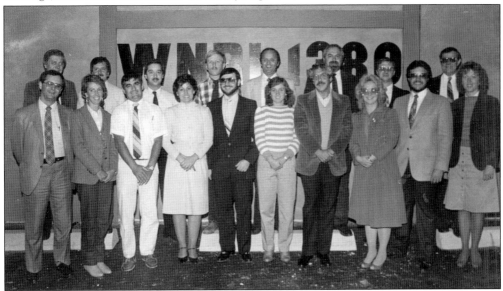

This photograph from a slightly earlier time, around 1980, shows the WNRI staff posed in front of the studio building on Diamond Hill Road. Shown here are, from left to right, (first row) Roger Bouchard, Aurore Carriere, Romeo Berthiaume, Pat Gratton, Bobby Allen, Barbara Kafalas, David St. Onge, Lynn Parenteau, Paul Giammarco (also known as David Paul), and Lorraine Demers; (second row) Joe Struzik, Don Brunelle, Art Gallotello, Larry Poitras, Dick Bouchard, John Gregory, Ron Ouelette, and Frank Visgatis. (Courtesy Roger Bouchard.)

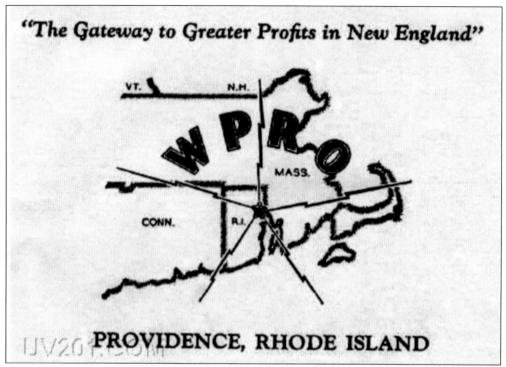

"The Gateway to Greater Profits in New England"

PROVIDENCE, RHODE ISLAND

This photograph shows a coverage map and the front of a rate card for WPRO, when the station was still owned and operated by Cherry & Webb at 1210 kHz in 1934. Located at 15 Chestnut Street in Providence, just a few blocks from the main store on Westminster, WPRO actually began as WKBF in 1924 at 1050 kHz, then WDWF and WLSI in 1925 at 800 kHz, and later 1090 in 1927 and 1210 in 1928; it merged with WFCI/WPAW in 1933. WPRO finally moved to its permanent and current home, at 630 kHz, in 1934. (Courtesy WPRO archives, UV201.com.)

W L O V - f. m.	RATE CARD			
	1 min.	5 min.	15 min.	30 min.
99.9 mc. 4000 Watts Full Time	One Time $7.00	$12.00	$22.00	$36.00
	13 Times 6.75	11.00	20.00	33.00
PROVIDENCE, POST OFFICE BOX 999	26 Times 6.50	10.00	18.00	30.00
GAspee 1-9291	52 Times 6.25	9.00	16.00	27.00
	104 Times 6.00	8.00	14.00	24.00
The NEIGHBORLY BROADCASTING CO.				
NEW & MODERN PROGRAMMING	POPS	JAZZ	Show Tunes	Dinner Music

Shown here is a rate card (front and back) for WLOV-FM 99.9, licensed to Cranston for a brief period in 1958–1959. Numerous FCC violations caused the station to cease operations in 1961 for what was termed "misrepresentation," never to surface on the air again. (Courtesy Bill Corsair.)

56

Four

ONCE AN ISLANDER, ALWAYS AN ISLANDER

WADK-AM in Newport signed on in 1948 as WRJM (named for Reeny and John Molloy, the first owners), Aquidneck Island's first radio station. For more than 60 years, WADK has largely stayed with what has worked for them so well: community events, talking about their neighbors, advertising their businesses, and covering the local schools.

WRJM began a tradition that lasts to this day—broadcasting Thanksgiving Day high school football games—with the 1948 contest between Rogers and De La Salle at Freebody Park. Jerry Nevins was at the mic. In 1953, the call letters changed under new ownership to WADK (an abbreviation for "Aquidneck"), and the first local talk show took to the airwaves, hosted by Francis John Pershing Sullivan, known affectionately as "Sully." The station broadcast live coverage of community happenings—many of which can be considered major events by most standards—including the America's Cup races and the Newport Jazz Festival.

For the most part, Rhode Island has radio "dinosaurs" at both ends of the state (southeast in Newport, northwest in Woonsocket), stubbornly refusing to succumb to present-day practices and financial whimsy. How has this happened? Apparently, because these stations' "value is undeniable, and their reality is immeasurable" to the local communities in which they operate, according to Rhode Island Radio Hall of Famer Bobb Angel of WADK in Newport. "My greatest fear," Angel added, "is that we don't have younger radio professionals in the community willing to carry on this tradition."

	1 ti.	13 ti.	26 ti.	39 ti.	52 ti.	104 ti.	156 ti.	312 ti.
1 Hour	$60.00	57.00	55.50	54.00	52.50	51.00	49.50	48.00
½ hour	36.00	34.20	33.30	32.40	31.50	30.60	29.70	28.80
¼ hour	24.00	22.80	22.20	21.60	21.00	20.40	19.80	19.20
10 min.	15.00	14.25	13.87	13.50	13.12	12.75	12.37	12.00
5 min.	10.00	9.50	9.25	9.00	8.75	8.50	8.25	8.00
1 min. 100 words }	7.50	7.12	6.94	6.75	6.56	6.37	6.18	6.00
35 words	4.00	3.80	3.70	3.60	3.50	3.40	3.30	3.20

RATE CARD — October 1, 1948 — **WRJM** — 1540 KCS. 1000 WATTS

GENERAL BROADCASTING AND ADVERTISING

2. AGENCIES - 15% commission paid to recognized advertising agencies.

3. PAYMENTS - Bill due and payable when rendered - no cash discounts.

4. NEWS - Programs and news bulletins. Facilities: complete Associated Press News Service.

5. SPECIAL FEATURES - Time signals, weather forecasts, temperature reports, participating programs - information on request.

6. PROGRAM MATERIAL AND MUSIC LICENSES. Rates shown are for station time, services of announcer and station program staff in arranging programs; and copyright fees. Live talent and specially transcribed programs, wire lines for remote pickups available at cost.

7. POLITICAL - One time rates apply. Payment in advance.

8. GENERAL INFORMATION AND CONDITIONS

a. This rate card is for informative purpose only and does not constitute an offer of facilities by this company. Rates subject to change without notice.

b. No contract written for more than one year's service.

c. In the event of cancellation advertiser will be charged at the applicable rate for service rendered.

d. Advertising copy must be submitted 48 hours in advance.

e. All programs and announcements must comply with regulations of the F. C. C. and all Federal, State and Municipal laws.

f. The station management reserves the right to cancel or change the time of any program in order to substitute a program of special public interest.

Shown here is a rate card for WRJM 1540 AM, Newport, from October 1, 1948. The studios were located at 204 Thames Street. An advertiser could buy what amounted to a 30-second spot for $4, or less, depending on the number of spots bought. (Courtesy WADK, Bobb Angel.)

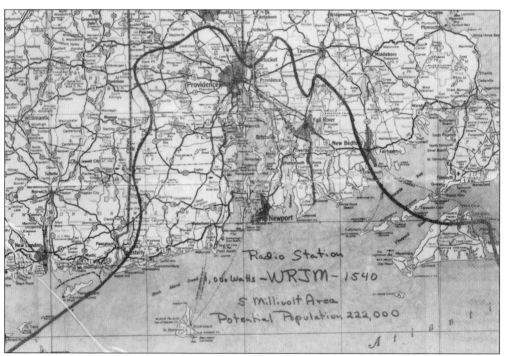

Shown here is a coverage map for WRJM when the station signed on in 1948. Note the notation of the station broadcast of 1,000 watts in a five-millivolt area with a potential population reach at the time of 222,000 (including most of Rhode Island, greater Providence, and Fall River, Massachusetts). (Courtesy WADK archives.)

This c. 1949 photograph shows an early 1540 AM remote inside of Newport City Hall. Note the presence of US Navy personnel in the audience as Dave Wolfenden ran the controls for the listeners over the airwaves. (Courtesy WADK archives.)

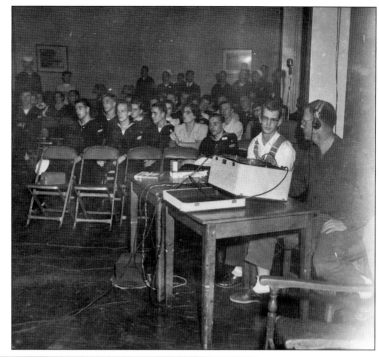

WADK technician Al Boman, shown here in the late 1960s, made fun of his "crabbiness" whenever something would go wrong. But he would find a way to make things work in the end—or so the story goes. (Courtesy WADK archives.)

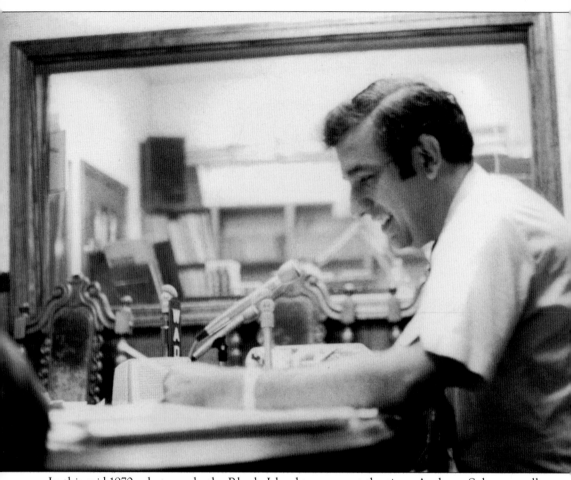

In this mid-1970s photograph, the Rhode Island treasurer at the time, Anthony Solomon, tells the listeners of Aquidneck Island about the state's financial matters. State officeholders frequently made the trek to the WADK studios to "get the message out." (Courtesy WADK archives.)

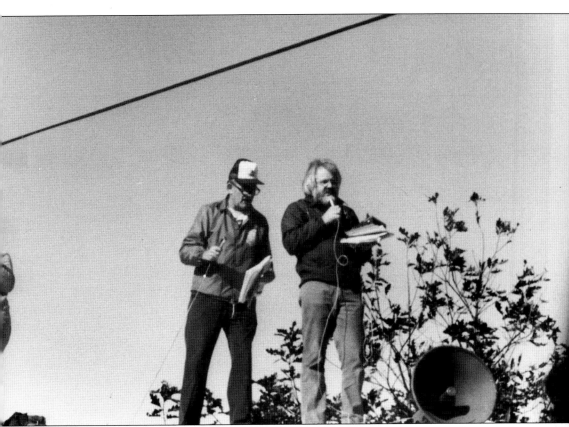

Bobb Angel (right) and Jerry Nevins sometimes had to improvise their setup, such as on this occasion in the mid-1970s during a remote broadcast for the Ocean State Marathon. The two were standing on the top of a school bus in order to get a clear view of the runners crossing the finish line. (Courtesy WADK, Bobb Angel.)

The United States of America

NUMBER
P3-1-71607

FEDERAL COMMUNICATIONS COMMISSION

RADIO TELEPHONE THIRD CLASS OPERATOR PERMIT
(Restricted Radiotelephone Certificate)

This certifies that ROBERT JAMES SULLIVAN

SEX	HEIGHT	WEIGHT	COLOR EYES	COLOR HAIR	DATE OF BIRTH
M	5'7"	180	BLUE	BROWN	SEPTEMBER 21, 1949

IS A LICENSED RADIO OPERATOR, AUTHORIZED, SUBJECT TO ANY SPECIAL ENDORSEMENT PLACED HEREON, TO OPERATE THE CLASSES OF LICENSED RADIO STATIONS FOR WHICH THIS CLASS OF LICENSE IS VALID UNDER THE ORDERS, RULES AND REGULATIONS OF THE FEDERAL COMMUNICATIONS COMMISSION, ANY STATUTE OF THE UNITED STATES AND ANY TREATY TO WHICH THE UNITED STATES IS A PARTY.

THIS LICENSE IS GRANTED UNDER THE AUTHORITY OF THE COMMUNICATIONS ACT OF 1934, AS AMENDED, AND THE TERMS AND CONDITIONS THEREOF AND OF ALL LEGISLATIVE ACTS, EXECUTIVE ORDERS, AND TREATIES TO WHICH THE UNITED STATES IS SIGNATORY, AND ALL ORDERS, RULES AND REGULATIONS OF THE FEDERAL COMMUNICATIONS COMMISSION, WHICH ARE BINDING UPON RADIO OPERATORS, ARE MADE A PART HEREOF AS THOUGH SPECIFICALLY SET OUT IN FULL HEREIN.

NEITHER THIS LICENSE NOR THE RIGHTS CERTIFIED TO HEREIN SHALL BE ASSIGNED OR OTHERWISE TRANSFERRED TO ANY OTHER PERSON.

PLACE AND DATE OF ISSUANCE: BOSTON, MASS. OCT 2 6 1979

DATE AND TIME OF EXPIRATION: OCT 2 6 1984 AT THREE O'CLOCK A. M., EASTERN STANDARD TIME.

SPECIAL ENDORSEMENT:

Federal Communications Commission

Signature of Licensee *Issuing Officer*

NOT VALID UNTIL SIGNED

Remember these? In order to operate the production board in a studio and play commercials, "board ops" at one time had to be licensed by the FCC. The certificate shown above was issued to WADK's Bob Sullivan in 1979 and covered a period of five years. (Courtesy WADK archives.)

Francis John Pershing Sullivan— known as "Sully" to his faithful listeners—was a huge talk influence on Aquidneck Island for parts of three decades. Sully's important voice was heard on the air from 1950 to 1977. (Courtesy WADK archives.)

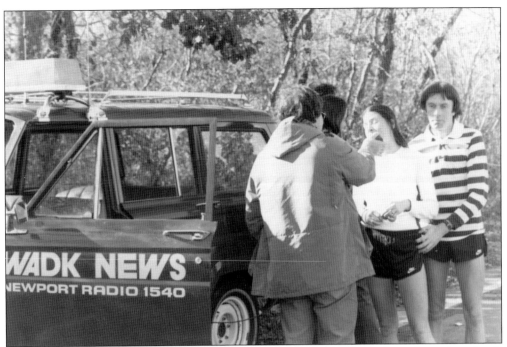

The WADK news jeep, shown here around 1978, was frequently seen throughout Aquidneck Island, out on the road for "man on the street" interviews. In this case, a "woman in the marathon" interview is being conducted during the Ocean State Marathon. (Courtesy WADK archives.)

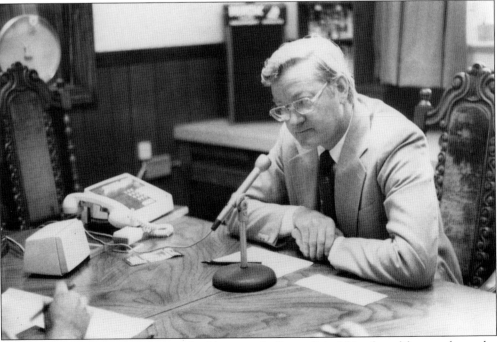

Rhode Island governor Joseph Garrahy, like several of his political friends and foes, made regular stops in Newport to visit the airwaves of WADK. This interview took place in the late 1970s. (Courtesy WADK archives.)

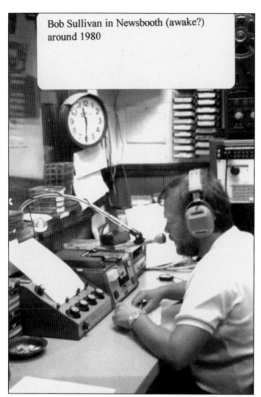

Bob Sullivan in Newsbooth (awake?) around 1980

"Round the clock coverage, whether listeners were awake to receive it or not." WADK newsman Bob Sullivan had things covered in the studio control room, even at 11:30 p.m. (note the clock in the photograph) during the nightshift in this c. 1980 photograph. (Courtesy WADK archives.)

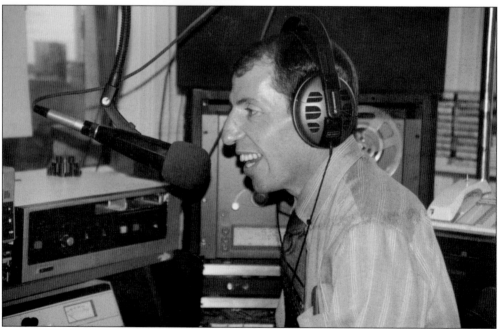

Art Berluti has been a regular on WADK for more than 20 years, presently serving as the news and public service director. His weekday morning show focuses on community news and events, an example of the kind of programming that has made WADK such an important part of the island way of life. (Courtesy WADK archives.)

Coverage of the Newport Jazz Festival has long been a programming staple for WADK. Since the first celebration began in 1954, the festivals have featured world-renowned jazz musicians and singers, bringing a worldwide industry focus to Aquidneck Island. Except for a 10-year period in the 1970s when the festival relocated to New York, Newport has been a jazz hot spot. And since signing on in 1948, AM 1540 has been a constant presence as Newport County's radio station of record. (Courtesy WADK archives.)

Providence's then mayor, Vincent A. "Buddy" Cianci, made frequent appearances on WADK, this one during his first term in office in the early 1980s. After leaving office following political scandal, Cianci hosted his own programs on WHJJ and WPRO and still hosts on WPRO today. (Courtesy WADK archives.)

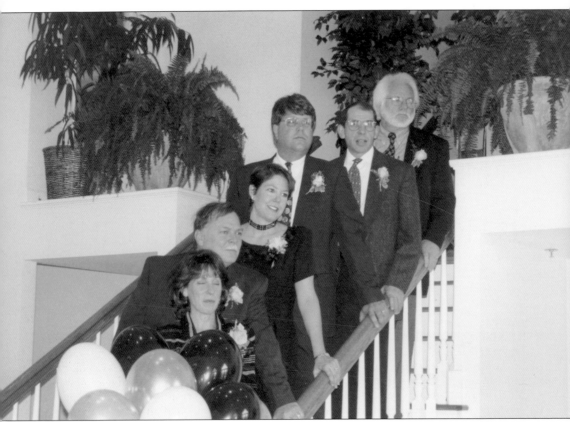

WADK celebrated 50 years on the air in 1998 with a gala (and remote broadcast, naturally) on Goat Island. Staff members pictured on the staircase are, from left to right, Cheryl Bickel, Bob Sullivan, Lisa McGuire, Bill Lancaster, Art Berluti, and Bobb Angel. (Courtesy WADK, Bobb Angel.)

Five

PERSONALITIES SHAPE RHODE ISLAND CULTURE

It all starts with Walter Leslie "Salty" Brine.

Many Rhode Island radio personalities have come and gone through the years, but no one else has had a state beach named after them. For more than half of a century, Brine was a colorful, cheerful, and comforting presence to local radio listeners, largely through his morning-show work on WPRO-AM from 1942 to 1993. Six different decades in the radio business is one thing, but six different decades at one radio station? Salty Brine is legendary, for more than just his folksy style and contagious smile. "Brush your teeth and say your prayers," was one of his signature sign-off phrases, while "No school, Foster-Gloucester!" was a highly anticipated announcement whenever snow fell on school days.

Through the years, it really has never mattered much to a local listener whether one is a current on-the-air personality, or a former one; once on the radio, he or she is always on the radio. Personalities give the news, and newspeople give their opinions—all broadcasters give a little of everything. As in most communities across America, disc jockeys and on-air personnel in Rhode Island have become beloved within their sphere of influence.

In some cases, these personalities have even been elected—and reelected. Former Providence mayor Buddy Cianci has been a fixture on local talk radio since the 1980s, albeit in an on-again, off-again manner, subject to his political career and subsequent incarceration on racketeering charges.

From Eddie Zack in the 1930s and 1940s, to Chuck Stevens in the 1950s, and Big Ange and the "WICE Guys" in the 1960s and 1970s, Rhode Island radio history has been marked by many notable personalities. For instance, former *Today Show* cohost and television news reporter Meredith Vieira began her career at WJAR radio, and regional and national sportscasters Mike Gorman (ESPN, Boston Celtics) and Don Orsillo (Turner Broadcasting, Boston Red Sox) have plied their trade on Ocean State airwaves. And some of the most recognizable local television faces and voices from the past (Salty Brine, Don Pardo, Jim Mendes, and Chris Clark, to name a few) share a common bond—they are most remembered, in Rhode Island, for their work in radio.

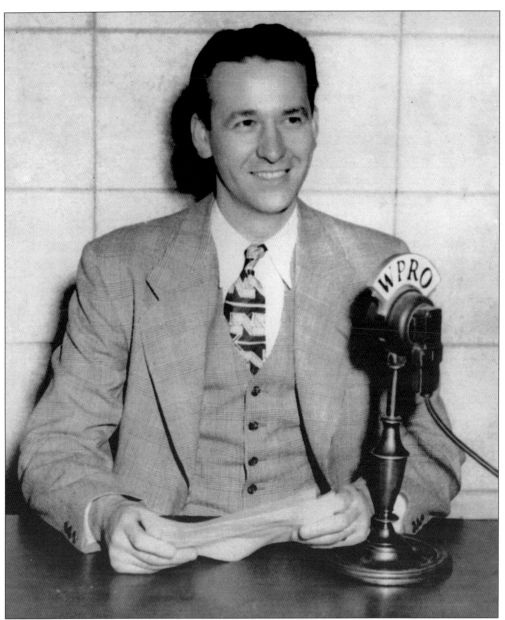

Walter Leslie "Salty" Brine was born on August 5, 1918. The morning-drive personality on WPRO-AM from 1942 (when this photograph was taken) to 1993—an astounding 51 years—he became a legendary figure in Rhode Island through his stories and folksy nature. He lost his leg at age 10 trying to jump a train near his home in Arlington, Massachusetts, and later in life he spent a lot of time visiting with children in hospitals who had also lost limbs. Salty's signature line, "Brush your teeth and say your prayers," was his sign-off to children from his *Salty's Shack* television show in the 1950s and 1960s, but he retained the line throughout the remainder of his career. On the occasion of his 35th anniversary on the air, in 1977, the WPRO studios on the Wampanoag Trail in East Providence were renamed the Brine Broadcasting Center. Brine was inducted into the Rhode Island Heritage Hall of Fame in 1979 and was posthumously inducted into the Rhode Island Radio Hall of Fame in 2008. (Courtesy Wally Brine.)

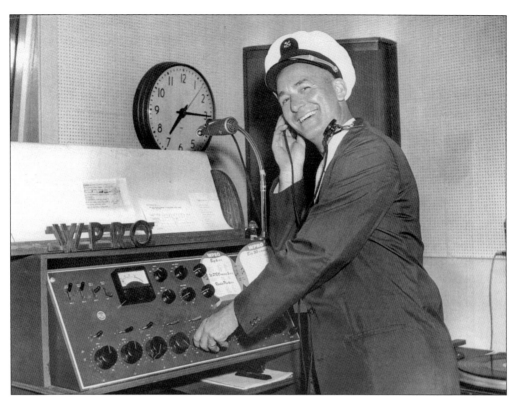

In 1990, Galilee State Beach in Narragansett was renamed Salty Brine State Beach. Brine passed away in 2004 at the age of 86. In the above photograph, Salty is running the program board in the WPRO studios in 1959. To the right is a c. 1960 WPRO promotional photograph autographed by Brine. A common belief exists that Salty's given surname was "Brien," or "Brian." Not so, according to his son Wally, a radio personality himself in Boston, who says his father's birth certificate lists his name as Walter Leslie Brine. Salty was a big Boston Red Sox fan; ironically, he was born when the Sox won a World Series (1918), and he passed away when the franchise finally won its next title (2004). (Courtesy Wally Brine.)

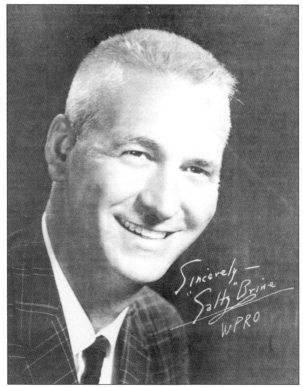

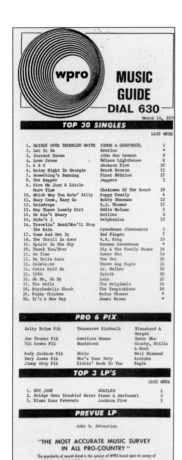

Shown here is the March 14, 1970, playlist of the Top 30 singles on the WPRO Music Guide. "Bridge Over Troubled Water" by Simon & Garfunkel was the top single, "Hey Jude" by the Beatles, the top LP. (Courtesy Jeff Falewicz collection.)

MUSIC GUIDE
DIAL 630

March 14, 1970

TOP 30 SINGLES

			LAST WEEK
1.	BRIDGE OVER TROUBLED WATER	SIMON & GARFUNKEL	1
2.	Let It Be	Beatles	*
3.	Instant Karma	John Ono Lennon	8
4.	Love Grows	Edison Lighthouse	9
5.	A B C	Jackson Five	22
6.	Rainy Night In Georgia	Brook Benton	11
7.	Something's Burning	First Edition	27
8.	The Rapper	Jaggers	3
9.	Give Me Just A Little More Time	Chairmen Of The Board	18
10.	Which Way You Goin' Billy	Poppy Family	6
11.	Easy Come, Easy Go	Bobby Sherman	12
12.	Raindrops	B.J. Thomas	17
13.	Hey There Lonely Girl	Eddie Holman	5
14.	He Ain't Heavy	Hollies	4
15.	Didn't I	Delphonics	15
16.	Travelin' Band/Who'll Stop The Rain	Creedence Clearwater	2
17.	Come And Get It	Bad Finger	7
18.	The Thrill Is Gone	B.B. King	23
19.	Spirit In The Sky	Norman Greenbaum	*
20.	Thank You/Star	Sly & The Family Stone	16
21.	No Time	Guess Who	14
22.	Ma Belle Amie	Tee Set	19
23.	Celebrate	Three Dog Night	21
24.	Gotta Hold On	Jr. Walker	30
25.	1984	Spirit	20
26.	Oh Me, Oh My	LuLu	25
27.	The Bells	The Originals	24
28.	Psychedelic Shack	The Temptations	10
29.	Funky Chicken	Rufus Thomas	*
30.	It's A New Day	James Brown	*

PRO 6 PIX

Salty Brine Pik	Tennessee Birdwalk	Blanchard & Morgan
Joe Thomas Pik	American Woman	Guess Who
Vik Arpen Pik	Woodstock	Crosby, Stills & Nash
Andy Jackson Pik	Shilo	Neil Diamond
Davy Jones Pik	Who's Your Baby	Archies
Jimmy Gray Pik	Kickin' Back To You	Eagle

TOP 3 LP'S

			LAST WEEK
1.	HEY JUDE	BEATLES	1
2.	Bridge Over Troubled Water	Simon & Garfunkel	2
3.	Diana Ross Presents	Jackson Five	3

PREVUE LP

John B. Sebastian

"THE MOST ACCURATE MUSIC SURVEY IN ALL PRO-COUNTRY"

The popularity of records listed is the opinion of WPRO based upon its survey of record sales compiled with listener requests.

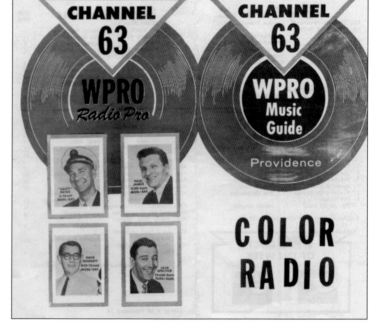

Color radio? That's how WPRO, "Channel 63," billed itself in the early to mid-1960s. "The Theme from A Summer Place" was number 1 on the singles chart on February 19, 1965. (Courtesy Jeff Falewicz collection.)

70

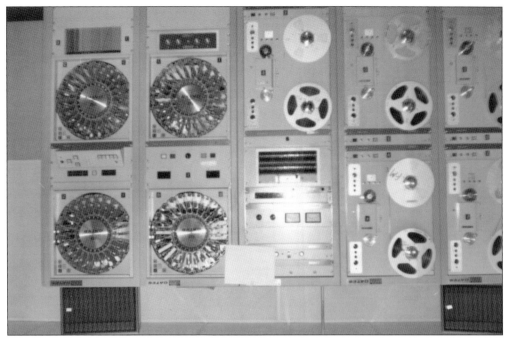

Shown here is the automation system in place in 1974 at WPRO-FM, 92.3, just before the station was relaunched and rebranded, turning AM radio on its collective ear with the move to a Top 40 format as 92 PRO-FM. (Courtesy Gary Berkowitz.)

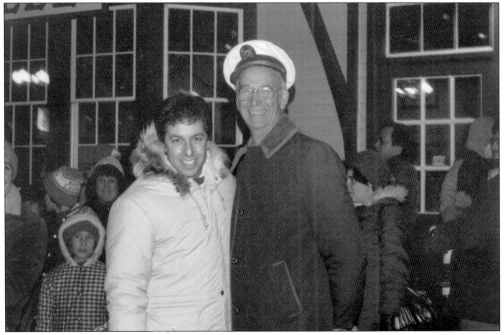

All aboard! Gary Berkowitz (also known as Gary Daniels) and the legendary Walter Leslie "Salty" Brine are shown here at the Edaville Railroad for a 63 WPRO promotion in the mid-1970s. The Edaville Railroad is thought to be one of the oldest heritage railroads in the country, opening in 1947 in nearby South Carver, Massachusetts. (Courtesy Gary Berkowitz.)

Mike Sands was universally liked for his on-air abilities as well as for his off-air community involvement in Rhode Island radio. Sands passed away after a car accident in 1993, ironically, while involved with a charitable outing. Known as "Surfer" Sands at WICE, Mike also spent time as program director and on-air talent at WJAR and was public affairs director and midday host at WSNE at the time of his death. (Courtesy WSNE.)

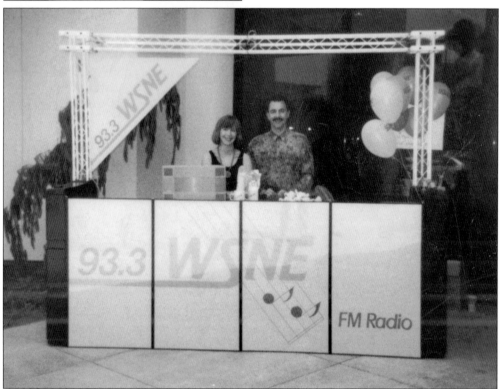

For 17 years on 93.3 WSNE-FM, David Jones and Joan Edwardsen ("Jones and Joan") stayed at or near the top of morning radio ratings with their program. They were the country's longest running, non-married, male-female duo at the same station. (Courtesy Vin Ciavatta.)

A newspaper advertisement celebrates Crescent Park's 81st birthday in 1977, featuring headshots of several WPRO on-air personalities. Larry Kruger, Salty Brine, Holland Cooke, Gary DeGraide, and Jimmy Gray were among the broadcasters slated to take part in a "DJ" competition. (Courtesy Holland Cooke.)

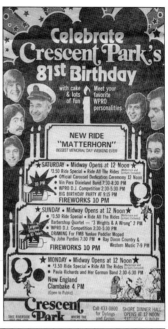

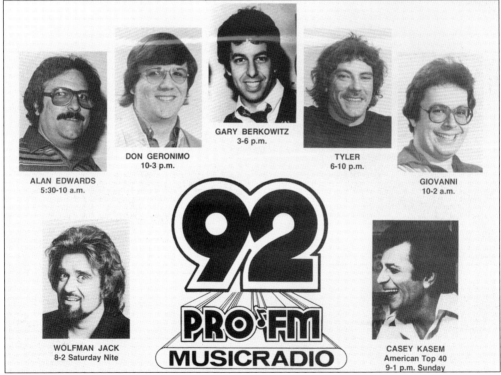

Shown here are promotional photographs of the 92 PRO-FM Musicradio staff from the mid-1970s. The local personalities are as follows: Alan Edwards (5:30 a.m.–10:00 a.m.), Don Geronimo (10:00 a.m.–3 p.m.), Gary Berkowitz (3:00 p.m.–6:00 p.m.), Tyler (6:00 p.m.–10:00 p.m.), and Giovanni (10:00 p.m.–2:00 a.m.). Wolfman Jack and Casey Kasem were aired in syndication. (Courtesy Holland Cooke.)

In the early 1970s, WPRO was still considered a Top 40 powerhouse on the AM side. It was getting ready to turn the corner on the FM side with the new 92 PRO-FM, featuring the on-air personalities shown here. From left to right are Gary DeGraide, Holland Cooke, Larry Kruger (standing), and Jimmy Gray. (Courtesy Holland Cooke.)

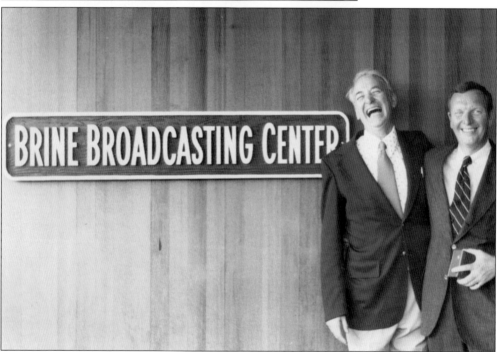

It was "Re-dedication Day" on the Wampanoag Trail in East Providence in 1977, on the occasion of Salty Brine's 35th anniversary on the air at WPRO. In this photograph, Salty (left) shares a laugh with then general manager Dick Rakovan at the unveiling of the new sign outside of the front entrance. It remains there today. (Courtesy Holland Cooke.)

Just after the national bicentennial celebration, this was the Big 10 LP Hits list on JB 105 FM, with Bill Silva (5:00 a.m.–9:00 a.m.). On August 1, 1975, WPJB-FM (which became known as the "Big Banger" and was owned by the Providence Journal Company) switched from classical to Top 40 and immediately rivaled 92 PRO-FM, which had switched to Top 40 in 1974 under the watch of Gary Berkowitz. (Courtesy Jeff Falewicz collection.)

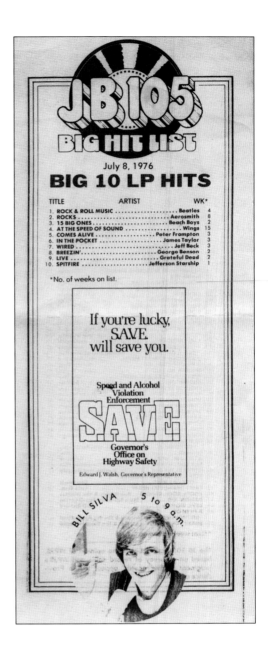

In the days before automation became prevalent, B101 (WWBB-FM) had a full, live, and local on-air staff. Featured in this 1992 promotional and coupon brochure are Paul Perry and Daria Bruno (5:30 a.m.–9:00 a.m.), Norm Thibeault (9:00 a.m.–1:00 p.m.), John Morgan (1:00 p.m.–4:00 p.m.), Cruisin' Bruce Palmer (4:00 p.m.–8:00 p.m.), Randy Saxx (8:00 p.m.–1:00 a.m.), and Roger Letendre (1:00 a.m.–5:30 a.m.). (Courtesy Jeff Falewicz collection.)

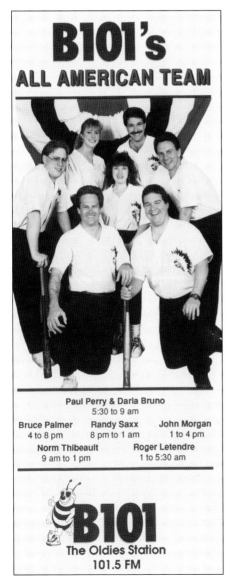

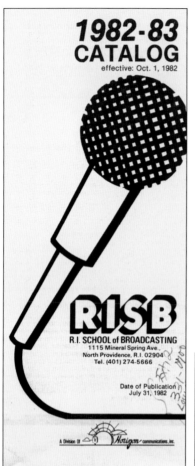

Does anyone remember the RISB? The Rhode Island School of Broadcasting was located on Mineral Spring Avenue in North Providence and offered courses in several areas. Vernon Stromberg was the president, Mike Cassiere ran the studios, and various local television and radio personnel taught the courses. The school opened in 1966. The course catalog shown here is from 1982–1983, just prior to the school's closing. (Courtesy Vin Ciavatta.)

Featured on the cover of this trade publication are snapshots of Rhode Island AM radio in the 1980s. Shown are, clockwise from upper left, the following: Dick Bouchard on the air at WNRI in Woonsocket; Salty Brine (left), weatherman John Ghiorse (center), and Larry Kruger on remote for WPRO; Vin E. McCoy at the mic hosting afternoons on WICE, whose staff included PD Jim Raposa and jock "Cousin Stevie" Bianchi; and Tony DiBiasio (left), former Providence mayor Joe Paolino (center), and Art Volpe on remote for WHJJ. (Courtesy Vin Ciavatta.)

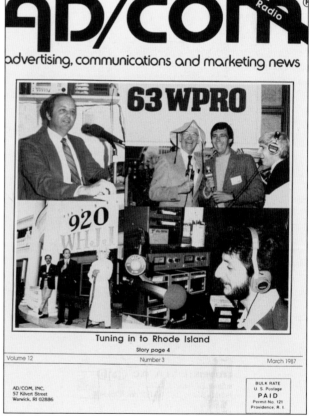

Shown here is the Tops in Pops list for the "Mighty 1290" WICE on the day after Christmas, 1960. The station billed itself as "R.I.'s Number One Station," telling listeners, "In Providence, hear the latest records first on WICE!" For this particular week, "Way Down Yonder in New Orleans" by Freddie Cannon led the playlist. (Courtesy Jeff Falewicz collection.)

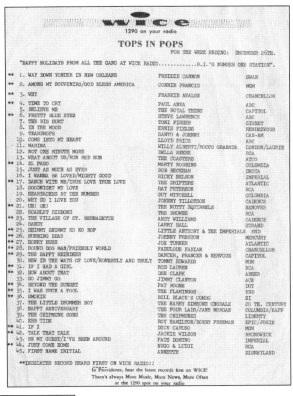

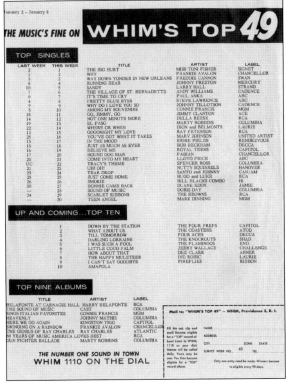

Shown here is WHIM's Top 49 playlist for the week of January 2–8, 1959. "The Big Hurt" by Miss Toni Fisher was at the top, but climbing into the rankings was a then little-known song from Doris Day, "The Sound of Music." At 1110 on the dial, WHIM billed itself as "The Number One Sound in Town!" (Courtesy Jeff Falewicz collection.)

WPRO reprimanded

WASHINGTON — Last Halloween Eve's broadcast of an updated version of H. G. Wells's "War of the Worlds" frightened so many listeners the Federal Communications Commission has reprimanded the Providence station involved.

The FCC yesterday, responding to complaints, reprimanded WPRO for not adequately assuring its listeners the program was not for real.

The broadcast was aired at 11 p.m. on Halloween Eve, 1974. And although it followed Wells' script—which itself prompted panic in New Jersey and New York when aired in 1938—the WPRO version had Martians invading Jamestown.

According to the FCC, the show violated a 1966 commission prohibition against "scare announcements or headlines which either are untrue or are worded in such a way as to mislead and frighten the public."

This 1975 newspaper clip details the "reprimand" received by WPRO for its Halloween Eve 1974 updated rebroadcast of H.G. Wells's "War of the Worlds." In the 1974 version of the 1938 original, Martians invaded Jamestown, frightening listeners and prompting the "slap on the wrist" by the FCC. (Courtesy Holland Cooke, *Providence Journal-Bulletin*.)

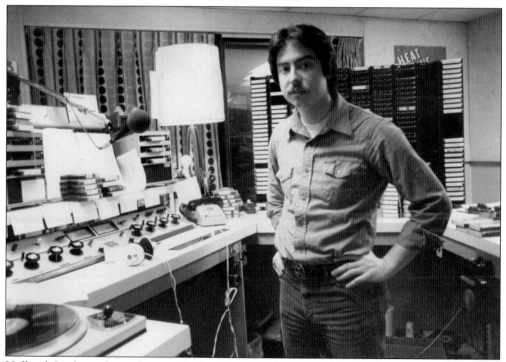

Holland Cooke is shown here in the WPRO studios around 1977. Count the cart machines—there were at least nine! Now a full-time consultant to the national and international talk radio industry, Cooke began by hosting the 7:00 p.m. to midnight shift on WPRO from 1974 to 1980. (Courtesy Holland Cooke.)

In this photograph, WSNE public affairs director and midday host Mike Sands (left), Vin McCoy (center), and Norm Thibault (right) are with an unidentified winning listener in Warwick at a station event and promotion for "Flashtype" in 1984. Currently known as Coast 93.3, WSNE began as WRLM in 1966, broadcasting local news and events in the vicinity of Taunton, Massachusetts, its city of license. The studios are located in Providence. (Courtesy Vin Ciavatta.)

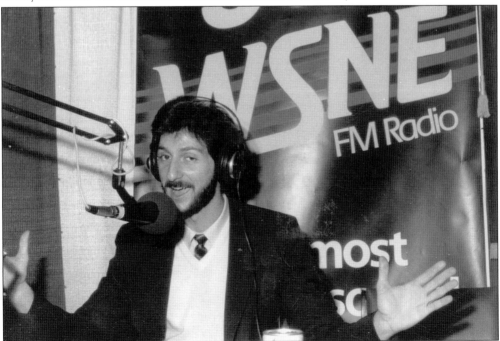

Vin McCoy (also known as Vin Ciavatta) hosts his afternoon program on a remote broadcast on 93.3 WSNE-FM, on November 4, 1984. The occasion was the Rhode Island Auto Show inside the Providence Civic Center, where a lucky listener won $10,000. (Courtesy Vin Ciavatta.)

I SURVIVED!
with 63 WPRO

It probably needs no explanation, but leave it to WPRO to survive, and capitalize, on the "Blizzard of '78." Several staffers, including Salty Brine, Jimmy Gray, and Holland Cooke, were "stranded" in the building on the Wampanoag Trail but managed to stay on the air and keep listeners informed around the clock. (Courtesy Holland Cooke.)

The Blizzard of 1978 was a monumental event and still talked about to this day. Rhode Islanders were stuck where they were—for days—including Gary Berkowitz (left) and Dan "Giovanni" Centofanti, who were holed up at the WPRO studios on the Wampanoag Trail. They managed to climb the freshly plowed snow in the WPRO parking lot in order to keep an eye on the roads. (Courtesy Gary Berkowitz.)

Mike Sands carried a lot of people during his career, including then WSNE intern Dave Herman. They are shown with Vin McCoy inside the WSNE production studio in 1985. Tragedy struck the station and the Rhode Island radio community in 1993 when Sands was killed in an automobile accident on his way to a station remote broadcast. (Courtesy Vin Ciavatta.)

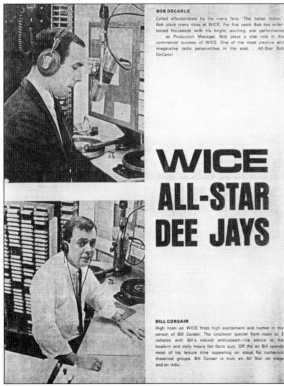

BOB DECARLO
Called affectionately by his many fans "The Italian Indian". Bob plays many roles at WICE. For five years Bob has entertained thousands with his bright, exciting, star performance as Production Manager. Bob plays a vital role in the commercial success of WICE. One of the most creative and imaginative radio personalities in the east. . . All-Star Bob DeCarlo!

WICE ALL-STAR DEE JAYS

BILL CORSAIR
High noon on WICE finds high excitement and humor in the person of Bill Corsair. The luncheon special from noon to 3 radiates with Bill's natural enthusiasm—his advice to the lovelorn and daily movie fan facts quiz. Off the air Bill spends most of his leisure time appearing on stage for numerous theatrical groups. Bill Corsair is truly an All Star on stage and on radio.

WICE's All-Star Dee Jays included Bob DeCarlo and Bill Corsair, shown here, as well as The Real Frank Smith, Malibu Mike, Al Fraser, and King Arthur Knight. Then located on the AM dial at 1290, "The Mighty 1290" was popular with its big sound, and even bigger personalities, during the 1960s. The station provided direct Top 40 competition against Channel 63, WPRO-AM. (Courtesy Jeff Falewicz collection.)

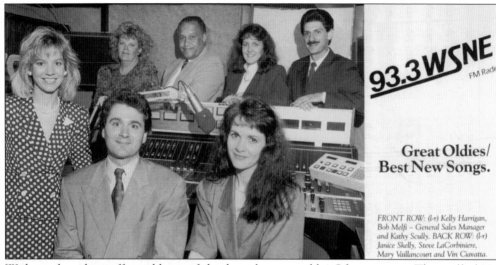

93.3 WSNE
FM Radio

Great Oldies/ Best New Songs.

FRONT ROW: (l-r) Kelly Harrigan, Bob Melfi – General Sales Manager and Kathy Scully. BACK ROW: (l-r) Janice Skelly, Steve LaCorbiniere, Mary Vaillancourt and Vin Ciavatta.

Without the sales staff, would any of this have been possible? Of course not. The staff of 93.3 WSNE in 1990 included, from left to right, (first row) Kelly Harrigan, Bob Melfi, and Kathy Scully; (second row) Janice Skelly, Steve LaCorbiniere, Mary Vaillancourt, and Vin Ciavatta. (Courtesy Vin Ciavatta.)

WDGE Contest Entry Form

99.7 THE EDGE

Name:_____

Address: _____

Phone: () _____

Fax: () _____

E-Mail: _____

Birthdate: _____

When do you listen to the **EDGE?** _____

CHUCK STEVENS
Radio Personality

100 John Street
Cumberland, RI 02864
401-725-9000

Rhode Island Radio Hall of Famer Chuck Stevens, inducted in the inaugural class of 2008, still plied his trade in 1986 at WICE, as attested to by his business card (left). One of the many incarnations of the 99.7 FM signal included WDGE "The Edge," featuring alternative rock, in the mid-to-late 1990s. (Courtesy Vin Ciavatta.)

Who remembers when 1450 AM was known as WSVP? The 1450 signal was home to WKRI and WWRI on the West Bay, serving the West Warwick area beginning in 1956. The call letters were changed to WSVP in 1970, and the station tried to challenge WPRO. They ultimately fell short of that goal, only able to broadcast at 250 watts of nighttime power. Jack Casey, who currently runs WERS at Emerson College in Boston, was the morning man in the early 1970s. (Courtesy Vin Ciavatta.)

HE JUST MIGHT BE YOUR CUP OF TEA.
HE'S JACK CASEY MORNINGS 5 to 10

Who loves a parade? Just about everyone in Rhode Island loves a parade, especially when it comes to Bristol and the Fourth of July. This early-1970s photograph depicts part of the WPRO 630 float, with Jack Casey (left, on float) and Big Ange (John Manzi, right, on float) as personalities along for the ride. (Courtesy Vin Ciavatta.)

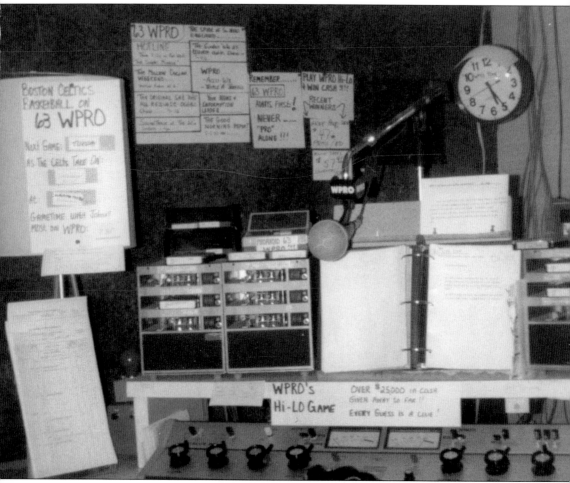

This c. 1982 photograph shows the WPRO-AM control room. Note the promotional liner of "Boston Celtics basketball on 63 WPRO" at the left and the reminder of WPRO's "Hi-Lo Game" above the console for whomever managed the dials during the day and night. (Courtesy Gary Berkowitz.)

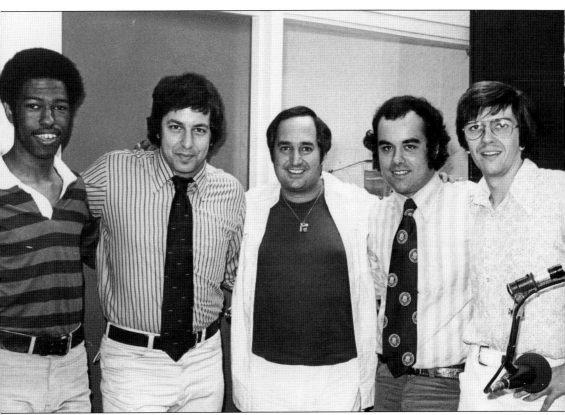

Studio visits were relatively commonplace in the 1970s and 1980s for recording artists pushing their songs and albums. Appearing at the old WPRO-FM studios on July 21, 1976, was recording star Neil Sedaka (center), along with, from left to right, "Mighty" Mike Osbourne, Gary Berkowitz, "Big John" Bina, and Chuck Bennett. (Courtesy Gary Berkowitz.)

Radio days meant promotion days, which in turn meant an opportunity to be seen in public. The "Boogie Man" (left), Gary Berkowitz (center), and Mike Osbourne are seen here at a summer promotion with the WPRO-FM "Beach Buggy." If the station is billed as the one that "reaches the beaches," it certainly makes sense to have a beach buggy. But was that in the budget? (Courtesy Gary Berkowitz.)

How about this Rocky Point newspaper advertisement, featuring the third annual WPRO "Battle of the Bands" competition? Note the promotion to see PRO's Holland Cooke break the flume ride record of 82 rides, set the previous year! There is no written (or otherwise remembered) documentation of the record being broken. (Courtesy Holland Cooke.)

Shown here in 1978 are, from left to right, WPRO-FM jocks Giovanni, Terry O'Brien, Gary Berkowitz, John Bina, and Howard Hoffman. The two-way radios were sometimes used to "cut in" during remote broadcasts from different locations within a contiguous site or location. (Courtesy Gary Berkowitz.)

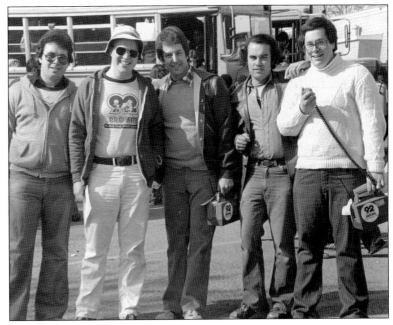

Promotional trips were (and sometimes still are) big deals for radio stations, and this WPRO trip to Walt Disney World in 1982 was no exception. Shown here during a television promotional shoot are, from left to right, Gary Berkowitz, Salty Brine, Larry Kruger, and John Palumbo. (Courtesy Gary Berkowitz.)

In the 1970s, there were not too many stars shining brighter than Henry Winkler (also known as Arthur Fonzarelli) of television's *Happy Days.* "The Fonz" made a promotional appearance with Gary Berkowitz on PRO-FM on April 23, 1976. (Courtesy Gary Berkowitz.)

The gang was (almost) all here in August 1977. In this photograph, the 92 PRO-FM jocks are, from left to right, Gary Berkowitz, Howard Hoffman, John Bina, and Dan Geronimo. This was the period when WPRO-FM really became known and branded as "PRO-FM." Bina was on the air in the mornings, Hoffman at night, and Berkowitz during the midday. (Courtesy Gary Berkowitz.)

Who can forget the days at Rocky Point? And the concerts, too? In this photograph, PRO-FM jocks at a Brownsville Station show in 1978 include Giovanni (third from left), John Bina (third from right), and Gary Berkowitz (second from right) pictured with band members. Apparently, no one was smokin' in the boys' room at this moment in September 1978. (Courtesy Gary Berkowitz.)

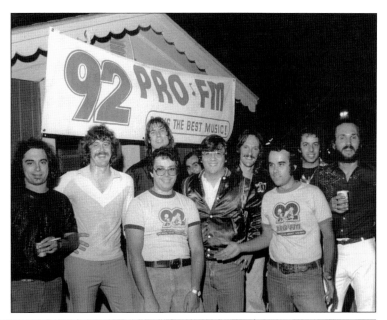

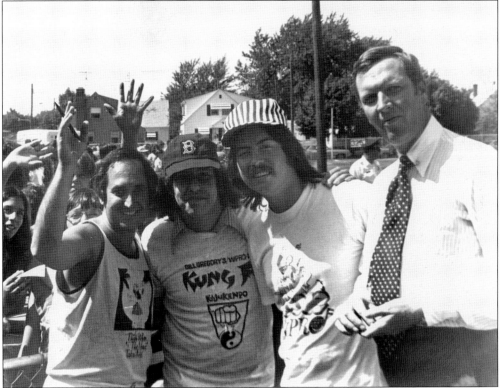

Shown here at a mid-1970s PRO-FM charity softball game are, from left to right, recording artist Neil Sedaka, Gary Berkowitz, Holland Cooke, and then general manager Dick Rakovan. Berkowitz became program director in 1974, moving over from WPRO-AM. Known as "Superock" starting in 1975, the station also identified itself as "FM-WPRO-FM" in order to differentiate itself from its sister AM side. (Courtesy Gary Berkowitz.)

She won a car! In June 1977, a PRO-FM listener won a new car and a set of luggage. She is shown here receiving the keys with, from left to right, Terry O'Brien, Howard Hoffman, and Gary Berkowitz. (Courtesy Gary Berkowitz.)

Who would not have wanted this opportunity? Backstage with The Beach Boys members Bruce Johnston (second row, left) and Mike Love (second row, second from right) in March 1982 were Jimmy Gray (second row, second from left), Gary Berkowitz (second row, second from right) and some lucky listeners. (Courtesy Gary Berkowitz.)

Bristol's annual Fourth of July parade in 1981 featured the "92 PRO-FM" float. Shown here are, from left to right, (first row) Tony Bristol, David Simpson, Gary Webster, and Rick O'Brien; (second row) Rod West, Tom Cuddy, Giovanni, Wolfman Jack, and Gary Berkowitz. (Courtesy Gary Berkowitz.)

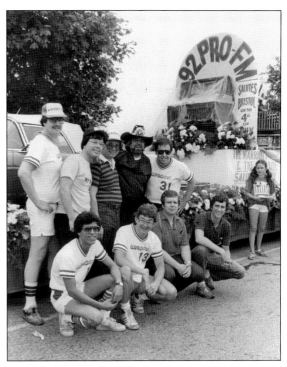

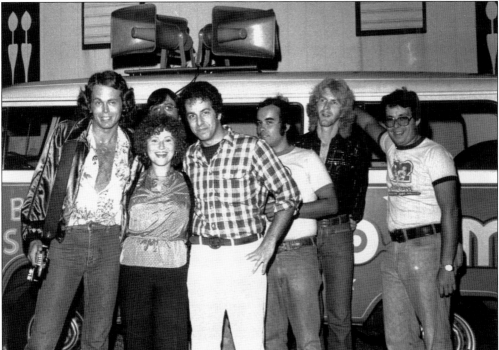

WPRO-FM jocks are shown here at Rocky Point in September 1978 with another star of the time, Walter Egan, who had a hit with "Magnet and Steel," from the album *Not Shy*. Among those in the photograph are Gary Berkowitz (center), John Bina (third from right), and Giovanni (right). (Courtesy Gary Berkowitz.)

Plenty of respect is shown here, as two listeners won the chance to meet comedian Rodney Dangerfield in January 1982. Also shown are Gary Berkowitz (left) and Jimmy Gray (right). This contest came during a time when PRO-FM began to reflect more of an adult influence; it remained the lone Top 40 station in Providence as Berkowitz departed for WROR in Boston. (Courtesy Gary Berkowitz.)

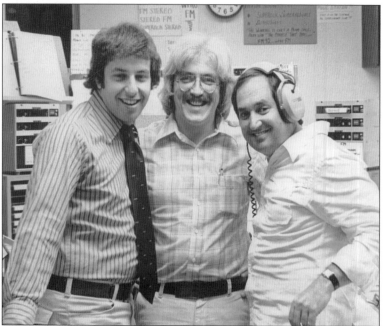

There is a star in the studio, as Neil Sedaka visits WPRO-FM for a live interview with Gary Berkowitz (left) and the "Boogie Man" on July 21, 1978. The "Boogie Man" left for WTIC-FM in Hartford later that year, while 20-year-old Dan Geronimo arrived from New York. (Courtesy Gary Berkowitz.)

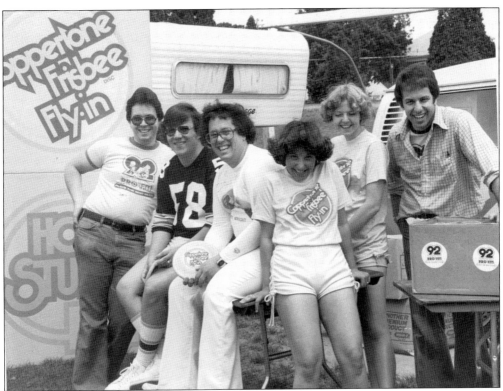

Everyone loves a promotion, including the staff. Shown above at the "Coppertone Frisbee Fly-In" in June 1978 are PRO-FM's promotional team and jocks. From left to right are Giovanni, Dan Geronimo, Howard Hoffman, two unidentified people, and Gary Berkowitz. PRO-FM began billing itself as "Southern New England's Most Listened to FM Station" and also "New England's Best Rock." Hoffman moved on to Houston, Texas, and eventually to WABC in New York later that year. (Courtesy Gary Berkowitz.)

"Musicradio" PRO-FM made an appearance at the Providence Civic Center around 1975, with on-air personalities, from left to right, Giovanni, Dan Geronimo, unidentified (background), and Gary Berkowitz. In the fall of 1975, the station's lineup was Berkowitz in the morning, followed by Chuck Bennett, "Boogie Man," "Mighty" Mike Osbourne, Big John Bina, and Giovanni. (Courtesy Gary Berkowitz.)

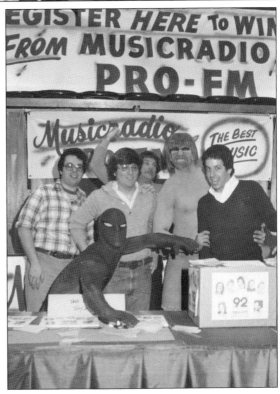

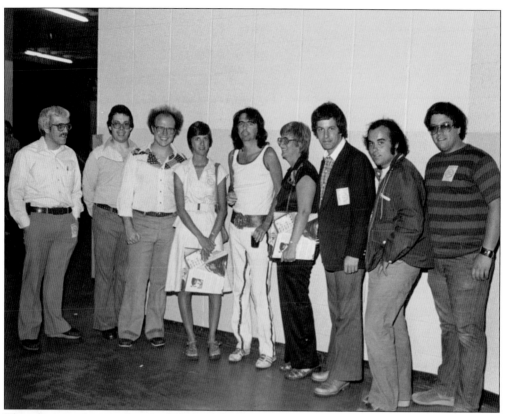

This photograph was taken backstage at the Providence Civic Center in July 1977 at the Alice Cooper concert. Shown here are, from left to right, "Boogie Man," Giovanni, Terry O'Brien, unidentified contest winner, Alice Cooper, unidentified contest winner, Gary Berkowitz, John Bina, and Howard Hoffman. (Courtesy Gary Berkowitz.)

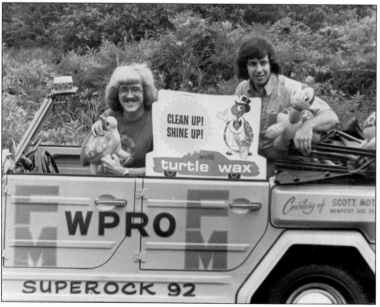

Stations gotta have a gimmick. And what better summertime gimmick to have than a station beach buggy? In the summer of 1975, "Boogie Man" (left) and Gary Berkowitz took part in a promotional shoot for the "Superock 92" WPRO-FM beach buggy. (Courtesy Gary Berkowitz.)

Shown here around 1977 is a billboard situated on top of the WSBE television studios on Mason Street in Providence. "There's always a better song on 92 PRO-FM" was part of a promotional campaign, which also included a "Where do you PRO-FM?" contest, as the PRO-FM brand began to take hold in the marketplace. (Courtesy Gary Berkowitz.)

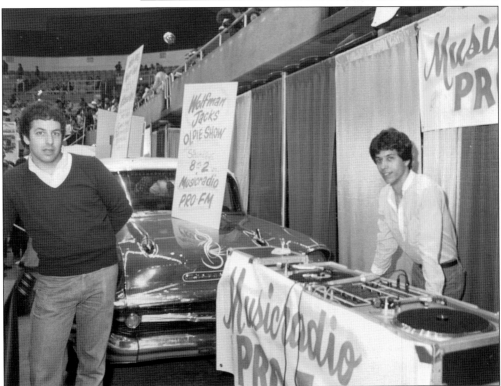

The Providence Civic Center, which opened in 1972, became the venue for just about every trade show, concert, and major promotion in the state of Rhode Island. Known as the Dunkin' Donuts Center today, it still pulls in its share of shows. In this photograph, Gary Berkowitz (left) and Tony Bristol set up a remote promoting Wolfman Jack's *Oldie Show*. (Courtesy Gary Berkowitz.)

Here is Gary Berkowitz (also known as Gary Daniels) in the rechristened 92 PRO-FM control room in 1976. Known for being an innovator of contemporary and Top 40 radio, Berkowitz also later programmed WROR Boston, WHYT, WJR, and WKQI in Detroit. He presently consults for several media companies and their station holdings. (Courtesy Gary Berkowitz.)

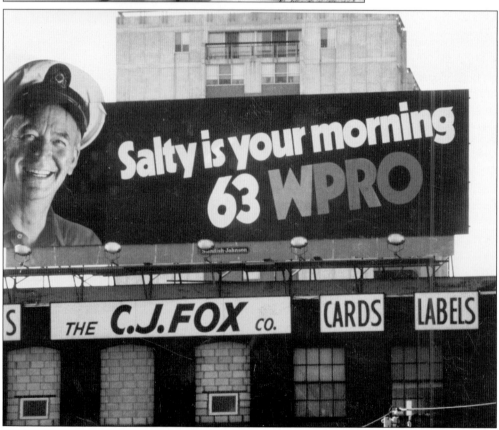

No last name is needed—a testament to the drawing power of one Walter Leslie "Salty" Brine. Shown here in September 1980 is a "Salty is your morning, 63 WPRO" billboard on I-95 at West Exchange Street in downtown Providence. (Courtesy Gary Berkowitz.)

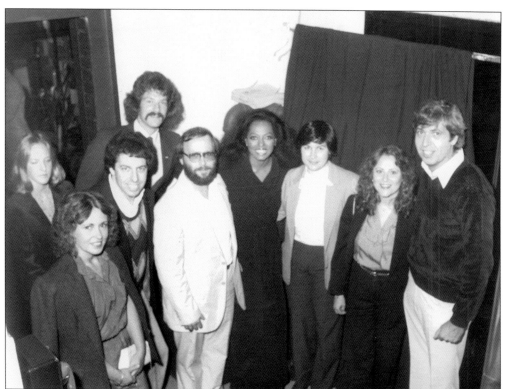

In this c. 1975 photograph, Diana Ross, on a concert tour stop, hits Rhode Island thanks in part to PRO-FM and Gary Berkowitz (third from left) and Jimmy Gray (right). (Courtesy Gary Berkowitz.)

PRO-FM's Gary Berkowitz (left) and WPRO-AM's Jimmy Gray (right), with the Diana Ross concert winners and Melody Gray, pose in front of the State. Gray moved from his popular midday time slot on WPRO-AM to the FM side in 1979 and began a successful 12-year run in the mornings on PRO-FM. (Courtesy Gary Berkowitz.)

Paul Fuller (left) and Al Matthews (right)—also known as Paul and Al, shown above in 2010 during a promotional shoot—have been paired for more than 20 years as the morning-drive duo on WHJY-FM. Long dominating the coveted 25–54 male demographic, their easygoing manner and sometimes outrageous humor have endeared them to a generation of 30-something and older listeners. The below photograph was snapped just after the two paired up for 94 HJY in 1990. Both men were inducted, as a team, into the Rhode Island Radio Hall of Fame's inaugural class in 2008. (Courtesy WHJY-FM.)

Two stalwart on-air performers during a dominant period for WHJY-FM were Carolyn Fox and her on-air sidekick, Rudy Cheeks. They are shown here performing at the Seafare Inn in Portsmouth during a 1989 holiday party. Fox introduced a saucy, sometimes raunchy, style of show to her listeners, and she was inducted into the Rhode Island Radio Hall of Fame in 2009. (Courtesy Dick Poholek.)

The legendary country music artist Eddie Zack (second from left), with Cousin Richie (right) and the Dude Ranchers, appeared at the Hayloft Jamboree on July 4, 1983, in Cumberland, Rhode Island. Also shown is WGNG-AM 550 morning personality Mark. Zack later broadcast his show on WJJF, almost up until his passing in 2002. (Courtesy Dick Poholek.)

In the early 1990s, Rocky Allen (right) and his on-air partner Blaine (left) kept WPRO-FM on top of the morning-drive ratings list. The two are pictured here with an unidentified listener and contest winner in 1994. Allen moved on from PRO-FM to WPLJ in New York soon thereafter. (Courtesy Dick Poholek.)

He is in BIG company. WPRO's Steve Kass (left) and an unidentified man pose with sumo wrestlers visiting the Brine Broadcasting Studios on the Wampanoag Trail in East Providence prior to the Newport Black Ships Festival in 1999. (Courtesy Dick Poholek.)

Remember JB 105? The forerunner to Lite 105, and the current Lite Rock 105, WWLI-FM was formerly the *Providence Journal-Bulletin*–owned WPJB. Sales executive Dick Poholek (left) is pictured here with JB 105 personality Al Norman (of Bill & Al) in 1979. (Courtesy Dick Poholek.)

WPRO-AM 630 flipped to a news/talk format in the late 1980s and dominated the marketplace for years. It still has a hold over competing AM stations in Rhode Island. The architect behind much of the move was then general manager Mitch Dolan, pictured at right with account executive Dick Poholek. (Courtesy Dick Poholek.)

Remember when AM 550 was WGNG Country? GNG stood for "Gold 'N Great," as the station was primarily a Top 40 competitor. GNG personality John Grube is shown here with recording star Eddie Rabbit on a promotional tour in the early 1980s. (Courtesy Dick Poholek.)

WHJJ-AM 920 was the market leader in news and information in the late 1980s, until a format flip by WPRO challenged (and eventually overtook) its supremacy. Among those shown in this photograph are Tony DiBiasio ("Eye in the Sky," third from left), then Providence mayor Joe Paolino (fourth from left), then program director Ron St. Pierre (with mic), John Morgan (second from right), and Art Volpe as "Father Time." (Courtesy Dick Poholek.)

demand radio 55! WXTR

PROVIDENCE
PAWTUCKET

Confirming Your Reports of

Date 1/26/08 00 H

WXTR 550 kc

1000 WATTS DAYTIME
500 WATTS NIGHTTIME

TRANSMITTER SITE IN CUMBERLAND, R. I.

This is a QSL (confirm transmission receipt) card confirming the reception of WXTR-AM 550 in Brooklyn, New York, by Ernest Cooper. It must have been a clear night on January 26, 1968, as WXTR transmitted just 500 watts from their site in Cumberland, Rhode Island. (Courtesy Ernest Cooper.)

Bill Corsair, one of the "WICE Guys" in the heyday of WICE-AM, is seen here in several iterations. A part of "Good Guy" Radio and later "All Star" Radio in the 1960s, Corsair was the original voice of the talking G.I. Joe action figure, made famous by Hasbro. (Courtesy Bill Corsair.)

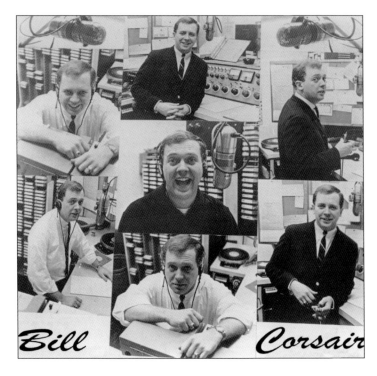

TV TALK takes a local to ...
Providence's WICE-Radio

That grin you see on Dr. Bill's face says he's freezing in January breeze.

DR. BILL CORSAIR

■ Every weekday afternoon from noon to three, New Englanders may cure all their ills by tuning in to **The Bill Corsair Show**. Dr. Bill brightens the day with lively patter—humor, movie news, and advice to troubled listeners. When Bill arrived at WICE, he introduced himself with a bizarre stunt. On New Year's Day he planned to take an icy dip in the waters of Narragansett Bay. And on January 1, 1966, he did just that after weeks of preparation. Another Corsair caper involved standing on top of a local auto dealer's roof until twenty used cars were sold. He reported in on the air every half hour, then, with the sale of the twentieth car, descended amidst cheers. Bill has been married to Janice Resnick since November, 1966. Before and since their marriage, the Corsairs have been active with the Providence Players of The Baker Playhouse. In fact they eloped between rehearsals (typical!). Although Bill and Janice as yet have no little Corsairs, they were not able to get away for a honeymoon until last January. Must be because Dr. Bill is just so busy! Reputed to be Dr. Feelgood of the Jet Set, it's no wonder that this musician, daredevil, actor, humorist, and all-purpose panacea keeps all his patients happy and healthy! ■

...Providence's WJAR-TV

JAY KROLL

Jay Kroll (left) carries on a stimulating discussion with exciting guests, Norwood Smith (center) and Betsy Palmer. It's a Providence coffee break.

■ Busy New England housewives, like their working husbands, deserve a coffee break. And they get one every morning with Jay Kroll on **Talk of the Town**. Jay's program features interesting guests and talk on travel and hobbies. His guests have included such celebrities as Ann-Margret and Gordon MacRae along with civic leaders from the Providence area. Jay marks his eleventh year with WJAR this year. In 1957 he began as host of **The Morning Show** and **The Afternoon Show**. Both programs offered film plays selected on request from Jay's fans. Jay's introduction to show business came via his dad, a semiprofessional in the music world. After attending Blair Academy and Upsala College, Jay went on to the Cambridge Radio and TV School. He says, "I've always loved show business and felt that one should do what he loved the most." Thus, after serving a three-year stint in the Navy (as boatswain's mate aboard the USS Constellation), Jay began his TV career with WELS-TV in Kingston, N.C. and WNCT-TV in Greenville, N.C. A desire for wider experience sent Jay to New York, where he appeared in numerous industrial films. Jay and his wife, Ann, who met in high school in New Jersey, have two children, Gary, twenty-three, and Judy, eighteen. They live in Barrington, R.I. ■

Items discussed in this issue of *Scene* magazine include WICE's "Battle of the Bands," a 13-week competition in which the winning local group won $1,000 and plenty of musical exposure on the station; disc jockey Bill Corsair coming out of Narragansett Bay after a plunge on New Year's Day; and recording stars Chad Stuart and Jeremy Clyde try to warm Bill up at the after-party. Corsair later moved on to host a highly rated overnight talk show on WCAU in Philadelphia. With psychic Howard Sheldon, Corsair set a Guinness world record when more than 355,000 callers attempted to phone into his show one evening. In 2003, Corsair won the prestigious Screen Actors Guild award for his role as the Movietone newsreel announcer in the award-winning film *Chicago*. (Courtesy Bill Corsair.)

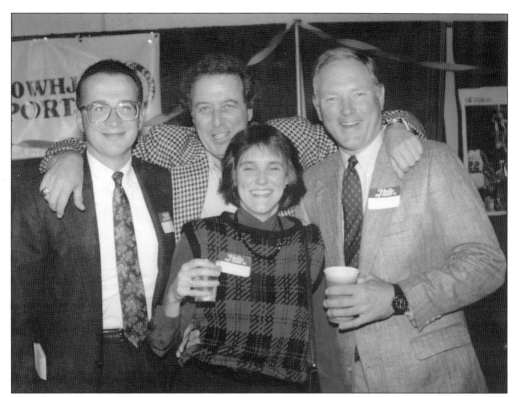

The above photograph shows a WHJJ/Boston Celtics preseason game at the Providence Civic Center in 1986. Shown are, from left to right, Dick Poholek, Steve Kass, Patty St. Pierre, and Bob Fish taking in the action and celebrating the partnership with a championship-caliber team. (Courtesy Dick Poholek.)

For more than 25 years, Geoff Charles has been a zany and entertaining host on several stations in Rhode Island, most recently on WHJY-FM in afternoon drive. In 1989, while with WPRO-AM, a live broadcast originating from between the Big Blue Bug's front legs (located on Interstate 95 and Thurbers Avenue in Providence overlooking the highway) caused two accidents on the road below. Afternoon commuters slowed to stare at the spectacle of a bare-chested Charles hamming it up with a belly dancer and a very attractive woman in a green bikini, and the stunt eventually sent six people to the hospital. (Courtesy WHJY.)

It was "Merv Day" at WHJJ/WHJY on April 25, 1990, when Merv Griffin Enterprises took over ownership of the two Rhode Island stations, which were then located in their former East Providence studios. Shown here in the first row are general manager Jim Corwin (left) and Griffin—television host, musician, actor, media owner, and game show creator—posing with station personnel gathered behind them for the occasion. Upon the sale of Merv Griffin Enterprises a short time later, Griffin was named the richest Hollywood performer in history by *Forbes* magazine. He passed away after battling cancer in 2007. (Courtesy Dick Poholek.)

On the last day of ownership by Cap Cities, WPRO-AM/FM held a celebration—and a retirement party—for Salty Brine. On April 29, 1993, an era in Rhode Island broadcasting history truly ended. Not only did ownership change (the station was purchased by TeleMedia), but it was the end of a 50-plus-year radio career for Salty Brine. In the above photograph, Brine (left) is pictured at the WPRO microphone with his longtime on-air sidekick, Larry Kruger. Below, Brine is pictured with his wife, Mickey (left), and WPRO's Barbara Smith at the station celebration on the Wampanoag Trail in East Providence after his final shift had ended. (Courtesy Barbara Smith.)

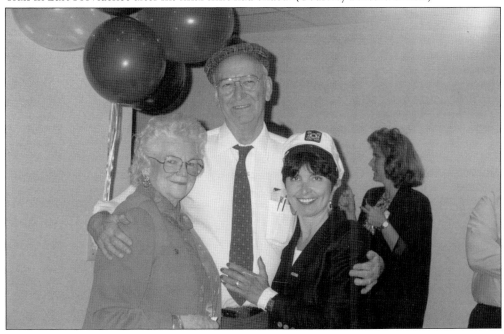

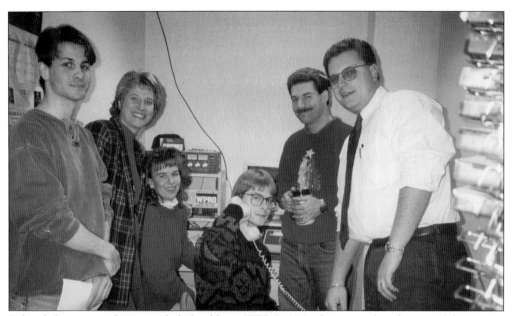

Behind the scenes, these people helped keep WPRO-AM relevant and at the top of the ratings book as the talk station transitioned from the Salty Brine era. Shown here taking time out during the holidays in December 1992 are, from left to right, Jeff Rainville, Karen Kutniewski, Rose Mulligan, Artie Tefft, Ron St. Pierre, and Gregg Perry. (Courtesy Barbara Smith.)

The morning drive team on WPRO-AM's *Salty Brine Show* pose for a photograph in the mid-1980s. Shown are, from left to right, sports anchor "Coach" John Colletto, news anchors Beverly Horne and Rhode Island Radio Hall of Famer Bud Toevs, Brine, Larry Kruger, and weather personality Elliott Abrams. (Courtesy Barbara Smith and John Colletto.)

Six

OPINIONS ARE EVERYWHERE

One thing Rhode Islanders love to do is give their opinions.

For many years, on many early stations, there was no such thing as a radio "format" and very little structure to the broadcast day. Early radio simply broadcast what was thought to be entertainment or information at that time—a basic principle that still applies today. WMCA in New York is widely credited with creating the first instance of "talk radio" in 1945, out of overall boredom from playing music. However, a national current events forum known as *America's Town Meeting of the Air* was broadcast once a week starting in 1935 on the NBC Blue Network and its successor, ABC Radio. The program featured panel discussions from newsmakers and personalities, while also allowing some level of audience participation.

In Rhode Island radio, several variety programs included what might now be considered talk show elements, including Ed Pearson's drive-time programs in the 1940s on WEAN and later on WPJB-FM. The same was true for Chuck Stevens in the 1950s, who often took phone calls from listeners on the air—even though his radio audience might not hear them! Veteran newsman Harry McKenna's weekly *Radio Press Conference* featured newsmakers and community leaders for parts of five decades, and his political ties and reporting on organized crime were widely recognized.

However, it took a concerted effort from former disc jockey and booth announcer Sherm Strickhouser to move Rhode Island radio full-time into issue-based, on-air discussions. Strickhouser has long been considered the "dean" of talk radio in Rhode Island, while strong personalities like Jack Comley, Steve Kass, Arlene Violet, and Mary Ann Sorrentino all brought passion and wit to their programs. Bob Crohan, former general manager at WICE, has been called the "godfather" of local talk radio because it was Crohan who brought Strickhouser and Comley into the format.

After talk radio began to fade somewhat in the 1960s and 1970s, John Franks revived local talk by hiring Strickhouser at WHIM and later Strickhouser and Kass at WHJJ. WPRO flipped its format to "newstalk" in the late 1980s and has been a major player in the discussion ever since.

WHY WE SAY

WEAN 79-0

IS AMERICA'S GREAT NEWS STATION

WEAN ("America's Great News Station") debuted as Rhode Island's first broadcasting station on June 5, 1922. WEAN published this double-sided flyer in 1961, touting the station's ability to cover the news for an entire state and region. The station aired 1,775 minutes of news every week, utilizing the facilities of the *Journal-Bulletin* newsroom and the expertise of CBS news and its reporters (below). The back side featured a coverage map and reach for the 790 AM signal, with advertising sales and demographic data included. After ownership changes in the 1980s, WEAN flipped to classical music WWAZ and eventually to adult standards under WLKW. (Both, courtesy Marie Louise Pearson, *Providence Journal-Bulletin* Sales Management Survey.)

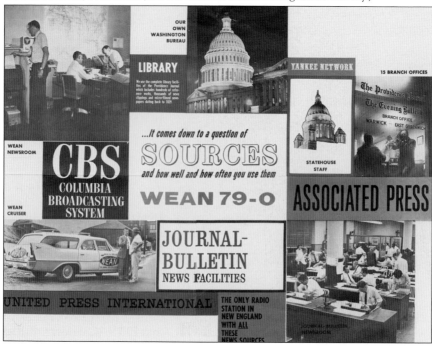

Jack Comley, one of the pioneers of the talk radio format in the Ocean State (along with Sherm Strickhouser), was a huge influence in the "entertainment" sector of radio in the 1960s and 1970s. A huge sports fan, he also did play-by-play and used his influence to contribute to the construction of the Providence Civic Center. Comley passed away in 1974 at the age of 41. (Courtesy Heath Comley.)

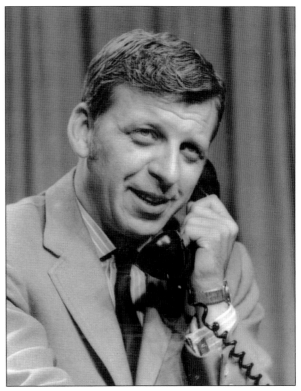

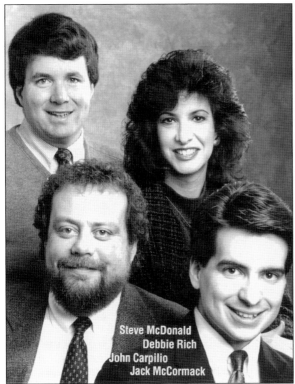

Steve McDonald
Debbie Rich
John Carpilio
Jack McCormack

The WHJJ-AM News Team, shown here in 1989, are, clockwise from upper left, sportscaster Steve McDonald, news anchor/reporter Deb Rich, Jack McCormack, and news director John Carpilio. They brought the day's events to listeners in an era before station cutbacks and consolidation became prevalent in the 1990s and 2000s. (Courtesy Deb Rich.)

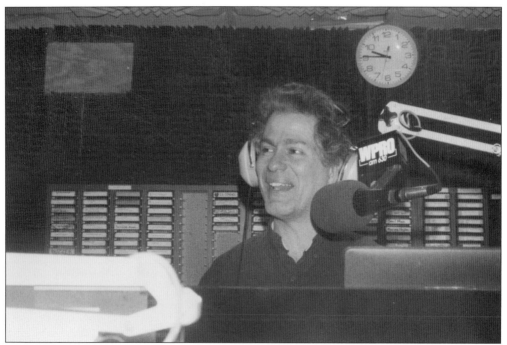

WPRO-AM was able to achieve ratings success after moving away from music programming and flipping to news/talk in the late 1980s, thanks in part to a stable of successful "Do It Yourself"–styled programs on the weekends. Known as "Drive Thru" radio, the shows were hosted by such professionals as Paul (pictured above) and John Zangari on car repair issues, dining out with Bruce Newbury (pictured below), pet care with Dr. Dan Simpson, legal tips, real estate advice, entertainment, technical issues, and more. Drive Thru radio is still on the air today as part of WPRO and sister station WPRV-AM 790's programming. (Courtesy Paul Zangari.)

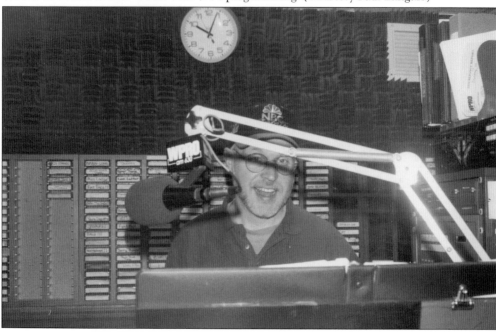

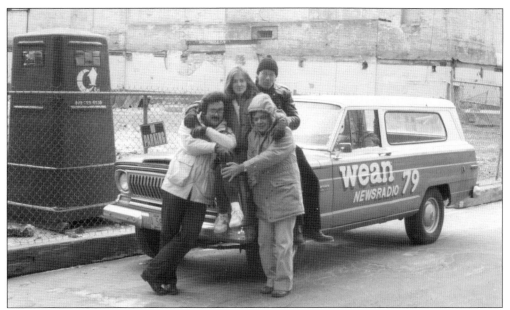

This photograph shows part of the WEAN Newsradio 79 team on a cold winter day in 1982. Striking a pose in front of their news vehicle are, from left to right, Mike Cabral, Caroline Magnan (on hood of car), Paul Zangari (on hood of car), and Bob Drake. WEAN was a music station in the 1950s, 1960s, and 1970s and became news/talk and newsradio in the late 1970s to mid-1980s as an affiliate of NBC's News and Information Service. (Courtesy Paul Zangari.)

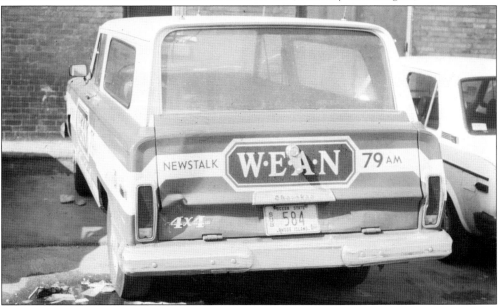

WEAN's mobile news vehicle is pictured here in the early 1980s. The Newsradio 790 studios were located at 290 Westminster Street in Providence, ironically, not far from their original location inside Shepard's Department Store in 1922 as Rhode Island's first broadcast outlet. After changes in ownership, WEAN-AM 790 became WWAZ, WLKW, and WSKO ("The Score") before its current iteration as WPRV Business 790, which is currently located in East Providence on the Wampanoag Trail. (Courtesy Paul Zangari.)

WPRO's Ron St. Pierre, himself a 2010 Rhode Island Radio Hall of Fame inductee, accepts induction for the late Sherm Strickhouser. Strickhouser began as a disc jockey and booth announcer in the 1950s and 1960s for WBRU, WJAR, and WICE and later became the "dean of talk radio" on dominant Rhode Island stations WHJJ and WPRO. (Courtesy Gene Hutnak Photography.)

A member of the inaugural class of the Rhode Island Radio Hall of Fame, former nun and Rhode Island attorney general Arlene Violet was known for never shying away from controversy. She usually dominated in her time slots over a 17-year run on WHJJ-AM, and she was named "Best Talk Show Host" for 16 straight years in *RI Monthly*'s readers' poll. (Courtesy Gene Hutnak Photography.)

Seven

SPORTS BROADCASTING

The first sports "broadcast" in the United States is thought to have come from the America's Cup races of 1899, as Guglielmo Marconi was brought to this country by the *New York Herald* to report on the races with his new technology—wireless telegraphy. Of course, Newport has long considered itself to be the true "home" of the America's Cup. It was not real radio then, as the first audio transmission of a sports event came on August 5, 1921, with the Pittsburgh Pirates playing the Philadelphia Phillies at Forbes Field in Pittsburgh.

Who gets credit for launching sports radio in Rhode Island?

Rhode Island has had notable teams and sports institutions, from the America's Cup to the early Reds' hockey teams, from Thanksgiving Day high school games to the PC Friars and URI (Rhode Island State) Rams of the 1950s and 1960s with Chris Clark, and from the Pawtucket Red Sox beginning in the 1970s to the Providence Bruins in the 1990s. And sports broadcasting personalities have made their presence felt. Chris Schenkel, a longtime broadcaster on ABC Television, once worked the racetrack at Narragansett Park. Gil Santos, who has spent more than 30 years as the radio voice of the New England Patriots, called the Friars for a few seasons, as did Mike Gorman, now the television voice of the Boston Celtics. Notable professional sportscasters Eric Reid, Don Orsillo, Gary Cohen, Dave Goucher, and John Sterling all worked here before moving on to bigger stages.

And let's not forget the legendary George Patrick Duffy. From high school sports to the Rhode Island Reds and almost every other event imaginable, Duffy was there to share it with his audience for parts of five decades.

Rhode Island, however, should also be noted as a birthplace for what is now known as "modern" sports talk. The first daily regular sports talk program, featuring guests of local and national significance, entered the state in the 1980s with *Chuck Wilson on Sports*. Wilson's ability to engage his audience and his interview subjects led him to ratings success and later a network position when ESPN Radio launched in the early 1990s. Much of ESPN's early programming was based on Wilson's shows (on WEAN, WICE, and WPRO), and Wilson is still on the air for the network today.

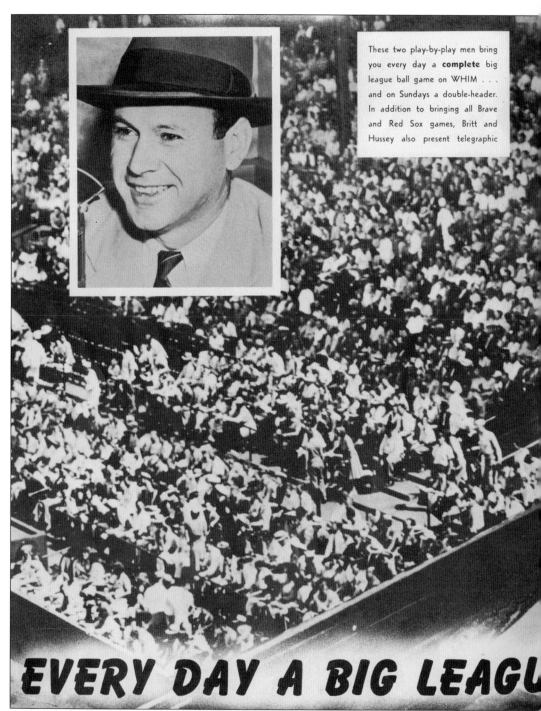

These two play-by-play men bring you every day a **complete** big league ball game on WHIM . . . and on Sundays a double-header. In addition to bringing all Brave and Red Sox games, Britt and Hussey also present telegraphic

EVERY DAY A BIG LEAGU

WHIM featured baseball coverage in the late 1940s, with Jim Britt (inset) and Tom Hussey (right) providing telegraphic re-creations of major league games. The station also carried live broadcasts of the Boston Red Sox and Boston Braves. From the 1920s and continuing primarily throughout the 1950s, many radio stations around the country found themselves without the budgets or technology to broadcast games live from the park. Instead, stations would re-create

re-creations of big league games in other cities (when the Boston teams have no game scheduled). These games are broadcast direct from Boston over the Narragansett Brewing Company and Atlantic Refining Company Baseball Network.

Narragansett Brewing Co. & Atlantic Refining Co. BASEBALL NETWORK

BALL GAME ON WHIM

the games in the studio. A telegraph operator would transmit the information from the ballpark to the studio, where broadcasters and engineers would re-create game action from the ticker tape. Crowd noise, the crack of the bat, the umpire on the field, and other sounds of the game were all manufactured in the studio as the game was being played live elsewhere. (Courtesy National Radio Personalities, General Photo, Providence.)

SPORTS

WHIM is preeminent in sports. Big League Boston baseball games are aired in the summer along with New England College football games including those at Brown and Holy Cross. A full program of schoolboy sports is also featured for the listening audience. A highlight of last fall was the broadcast of the LaSalle-Central football game over WHIM by Tom Hussey. Lou Farber, WHIM's Sports Director, is coach of East Providence High School and a member of the famed Brown University 'Iron Man' team. A former President of the R. I. Coaches Association, he is one of the outstanding figures in schoolboy sports in the state. Other WHIM activities include American Legion, Junior Baseball, schoolboy football, baseball and track broadcasts.

Left: Lou Farber, Sports Director of WHIM.
Below: Brown Field, Brown University — where are played many thrilling games aired by WHIM.

Lou Farber, a former coach at East Providence High School and a member of Brown's famed "Iron Man" team of 1926, served as WHIM's sports director in the late 1940s. Jim Britt and Tom Hussey provided much of the play-by-play of local events, including Brown football, American Legion baseball, and high school football, baseball, and track broadcasts. From the WHIM newsroom, Tod Williams and "Trusty" the rooster provided news for the farm folks every morning at 6:30 a.m. (Courtesy National Radio Personalities.)

Maury Lowe was called the "commercial representative and special events commentator" for WEAN in 1940, but in reality Lowe was one of the first sportscasters in Rhode Island radio. His shows included *High and Prep Schools Sports Roundup, WEAN Spelling Bee*, and coaches' shows, featuring Brown football coach Tuss McLaughrey. (Courtesy National Radio Personalities, Joseph Marcello.)

Sports Radio was alive and well in the 1950s. Shown here are two newspaper advertisements from the *Providence Journal-Bulletin*, previewing high school football broadcasts over WPJB-FM, 105.1. A weekly sports feature, with Barney Madden of the *Journal and Evening Bulletin*, ran at 7:30 p.m., while Jim Hines and Ed Pearson brought the action to listeners. Even though there were four different teams and schools involved, both games were played at Pierce Memorial Stadium in East Providence. (Courtesy Marie Louise Pearson.)

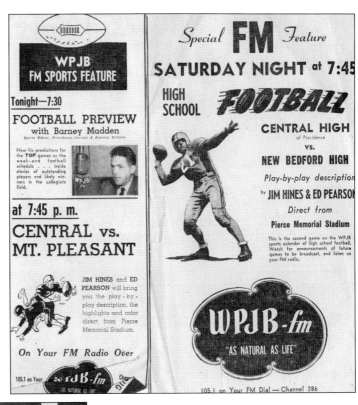

Beecroft Chevrolet, located on Niantic Avenue in Providence, took out this advertisement in the *Providence Journal-Bulletin* to promote "Star Night" on June 25, 1965, with appearances from several DJs and sports personalities at the time. Among the personalities of note were PC coach Joe Mullaney, Friars' radio voice Chris Clark, Salty Brine, Eddie Zack, and the Celtics' Tom Heinsohn. (Courtesy Marie Louise Pearson, *Providence Journal-Bulletin*.)

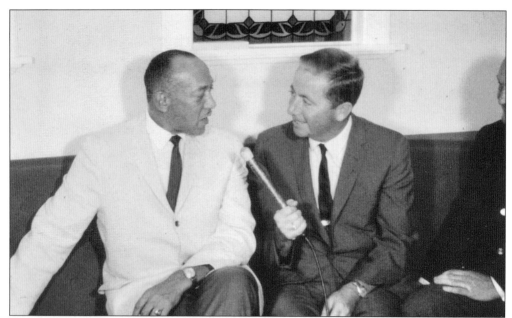

Chris Clark was the first sportscaster in Rhode Island to achieve true notoriety when he began calling games on the radio for Providence College in 1959, and the Friars won NIT titles in 1961 and 1963. For 25 years, as the original "Voice of the Friars," Clark captured the state's passion for sports through his work on WJAR and WPRO radio as well as on television. Here, Clark interviews Olympic hall of fame sprinter Jesse Owens in the mid-1960s. (Courtesy Donald Clark.)

Coverage of PC basketball on local radio has been a huge part of Rhode Island's broadcast heritage since 1959. Pictured here are play-by-play voice John Rooke (left) and Friar all-American Joe Hassett (center), who have been together on the air for parts of four decades, and statistician John Zannini (also known as the "Statbeast.") This photograph of the broadcast team was taken in March 2010, on the road in Louisville, Kentucky. (Courtesy author's collection, David Silverman.)

Chuck Wilson helped to launch the ESPN Radio Network in Bristol, Connecticut, in 1991, following a decade spent at WEAN, WICE, and WPRO. Wilson left ESPN for a brief period in the mid-2000s to go to Sirius/XM's Major League Baseball channel, then returned to Bristol in 2010. Having moved to Connecticut when he first left Rhode Island to work for ESPN, Wilson is back as a resident of the Ocean State today. (Courtesy Chuck Wilson, ESPN.)

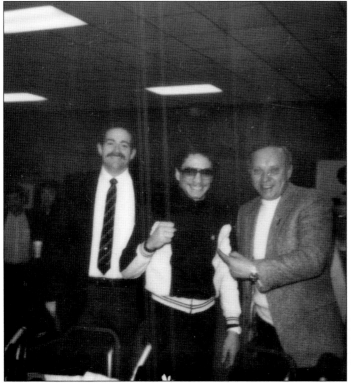

Dave Abrahamson (left) and Dick Higgins (right) hosted a very popular sports talk radio program, *Dick & Dave Sports Talk*, on 920 WHJJ in the 1980s and into the early 1990s as a direct competitor to *Chuck Wilson on Sports* on WEAN, WICE, and WPRO. Pictured here with former world boxing champion Vinny Pazienza, Dick and Dave got their gig by simply being a couple of regular guys. (Courtesy Dick Poholek.)

WSKO-AM 790 "The Score" launched a full-time sports format in 1997, eventually expanding to a simulcast on 99.7 FM. Pictured here after the Providence Bruins claimed the AHL Calder Cup in 1999 are, from left to right, (first row) Bruins' executives Randy Scott and Adam Alper; (second row) assistant coach Bill Armstrong, play-by-play announcer Dave Goucher, John Colletto, Andy Gresh, coach Peter Laviolette, and Steve King. Other Score show hosts included Amy Lawrence, Kevin Winter, Scott Zolak, John Rooke, Steve Hyder, Scott Cordischi, Byran Morry, and Jess Atkinson. (Courtesy John Colletto.)

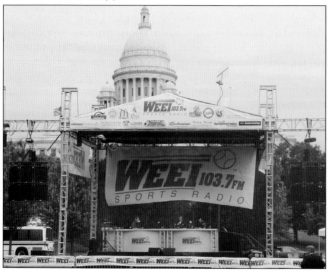

The launch of Sports Radio 103.7 WEEI-FM (now WVEI-FM) in Providence in 2004 helped lead to the demise of WSKO. Boston-based New England sports talk, featuring the Boston and New England teams, dominated the airwaves and came to stay. Dale Arnold, Red Sox slugger David Ortiz, and Bob Neumeier hosted their afternoon show live on location in downtown Providence on April 16, 2004, which was the inaugural broadcast day in Rhode Island. (Courtesy WEEI-FM.)

Eight
PRESERVING THE HISTORY AND TRADITION

It really started in a pub—pretty typical in Rhode Island. Early in 2008, the Rhode Island Radio Hall of Fame was created to celebrate and preserve memorabilia, radio equipment, audio, and written and oral history of radio in Rhode Island.

Credit must be given to the Texas and Georgia Radio Halls of Fame, as their expertise in putting together a vehicle to acknowledge the industry in their states served as a model for the RIRHOF.

Initially, a group of people with strong ties to radio in the state came together to form the first board of directors for the hall of fame. The board consists of on-air personalities, production people, station management, and sales executives.

For such a small state, size-wise, Rhode Island has dozens of notable personalities—on the air and off— deserving of induction into the hall. The board by itself, however, cannot recognize everyone.

As such, anyone with an interest in radio may become an associate member of the Rhode Island Radio Hall of Fame. Associate membership allows an individual the opportunity to nominate and vote for future inductees into the hall, to donate memorabilia, and to support the radio industry in the Ocean State as well as local charitable causes. The website for the RIRHOF is www.rirhof.org.

The first class of inductees, in 2008, featured true state legends—Salty Brine, Sherm Strickhouser, and Chris Clark, to name three. There simply would not be a hall without their inclusion. The goal each year is to find a "snapshot," a moment in time in different eras and programming formats, representing radio's growth, popularity, and professional acumen within our communities—including our pubs.

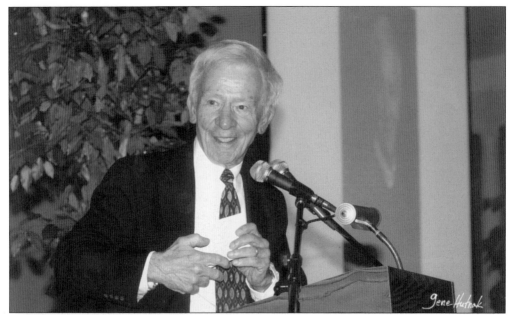

A gentleman, a professional, and a genuinely nice person, Charlie Jefferds, seen here in May 2008, had a deep, dulcet tone that graced Rhode Island airwaves for parts of six decades. Among his stops were WHIM, WICE, WJAR, WPRO, WWLI-FM, and more recently as an image voice for WPRV-AM 790. (Courtesy Gene Hutnak Photography.)

"Gentleman" Gene DeGraide (right) was one of Rhode Island's first star disc jockeys and radio show hosts, and he had a five-decade run on WWON, WJAR, and WKRI from the mid-1940s to the mid-1980s. He later became a popular spokesperson for a major auto dealership. Jefferds and DeGraide share a moment prior to both being inducted into the inaugural class of the Rhode Island Radio Hall of Fame in May 2008. (Courtesy Gene Hutnak Photography.)

Jimmy Gray was a popular, stand-out radio personality on WPRO-AM and FM for parts of three decades. He also worked at WHJJ and WCTK before retiring from the airwaves in the 2000s. Gray was inducted into the Rhode Island Radio Hall of Fame with the class of 2009. (Courtesy Jimmy Gray.)

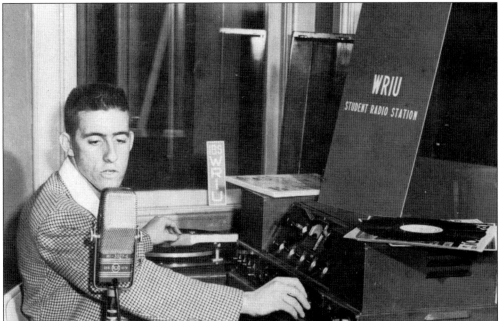

Jim Norman, longtime "Voice of the URI Rams" over parts of four decades, is pictured here as station manager for URI student station WRIU in 1956. Norman broadcast 1,286 consecutive football and basketball games for the Rams, until his retirement in the early 1990s, when he was succeeded on the air by Steve McDonald. Norman was also a former sports information director at the state university, and the press box at Meade Stadium on campus is named in his honor. (Courtesy URI Office of Publications and Creative Services.)

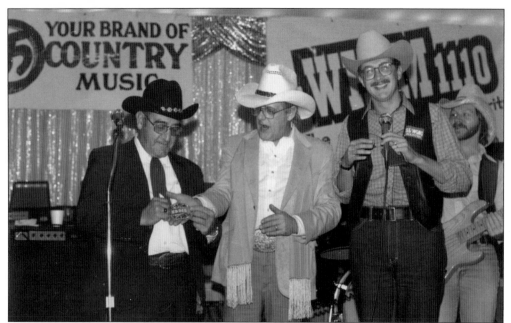

Eddie Zack (left) is at the 1983 Rhode Island Country Music Hall of Fame inductions, held at Rhodes on the Pawtuxet. Co-branded and promoted by both WGNG and WHIM, Zack performed on WRIB from 1958 to 1968; on WGNG, WKRI, and WHIM from 1990 to 1998; and hosted a program on WJJF until his death in 2002. (Courtesy Dick Poholek.)

The annual hall of fame induction ceremony and dinner takes place in May of each year and serves as not only a celebration of the 90-year history of radio in Rhode Island, but also as a reunion for those who work on and off the air. Class of 2008 inductee Al Matthews (left) visits with RIRHOF board member Joe Lembo (second from right) at a recent induction. (Courtesy Gene Hutnak Photography.)

As a teenager, Tony Bristol carried crates of record albums around for future hall of famers Giovanni, Mike "Surfer" Sands, "Mighty" Mike Osbourne, and Big John Bina. Eventually, he was hired by Gary Berkowitz on PRO-FM, given his radio name (his given name is Anthony Pescarino), and for 33 years he has been a key element in the continuing success of WPRO-FM as well as WWLI-FM (Lite Rock 105). Tony, pictured here with Barbara Smith, was inducted into the Rhode Island Radio Hall of Fame himself in 2012. (Courtesy Barbara Smith.)

They were two of a kind. Salty Brine and Larry Kruger, both inductees into the Rhode Island Radio Hall of Fame, posed for this promotional photograph in the mid-1980s. Salty and Larry woke up a generation of Rhode Islanders on weekday mornings on 63 WPRO with their stories, quick wit, news, weather, sports, and traffic reports. They made listeners feel right at home—even if they weren't. The two were paired on the morning show for 16 years (1977–1993). (Courtesy Barbara Smith, Suzie Sundlun.)

DISCOVER THOUSANDS OF LOCAL HISTORY BOOKS
FEATURING MILLIONS OF VINTAGE IMAGES

Arcadia Publishing, the leading local history publisher in the United States, is committed to making history accessible and meaningful through publishing books that celebrate and preserve the heritage of America's people and places.

Find more books like this at
www.arcadiapublishing.com

Search for your hometown history, your old stomping grounds, and even your favorite sports team.

MADE IN THE USA